MODELING A LIKENESS IN CLAY

MODELING A LIKENESS IN CLAY

BY DAISY GRUBBS

Watson-Guptill Publications, New York

Copyright © 1982 by Watson-Guptill Publications

First published 1982 in New York by Watson-Guptill Publications,
a division of Billboard Publications, Inc.,
1515 Broadway, New York, N.Y. 10036

Library of Congress Cataloging in Publication Data

Grubbs, Daisy.
 Modeling a likeness in clay.

 Bibliography: p.
 Includes index.
 1. Modeling. 2. Models (Clay, plaster, etc.)
I. Title.
NB1180.G77 1982 731.4'2 82-8418
ISBN 0-8230-3094-6 AACR2

Manufactured in U.S.A.

First Printing, 1982
3 4 5 6 7 8 9/87 86

TO DON

ACKNOWLEDGMENTS

First of all I would like to like to acknowledge the debt I owe my parents for their example of patience and persistence and for their belief that I could succeed at anything I undertook. I would also like to thank my aunt, Paula Kieffer, for the love of books and writing that she instilled in me together with a lifelong habit of consulting how-to books on every subject.

I would like to thank my teachers, Robert Morton and Marcus Aurelius Renzetti, both inspiring mentors. Next, I would like to express my appreciation to the Halstrick children, Carolyn, Richard, and Charles, who sat patiently for many early attempts at portraits, and also to the Grubbs boys, my second set of children—David, Daniel, Dawson, and Douglas—whose portraits appear in this book.

Then there is Alice Pritchard, my business partner, who first suggested the book; Urs, the artist-potter, who introduced me to the pleasures of working with porcelain; and Barbara Hails, who by writing an article for *American Artist* magazine introduced me to the publisher and urged me to try a book.

All of the models for this book deserve special thanks for their patient cooperation and trust. Marsha Melnick, my editor, has been a wonder of efficient planning, getting to the essence of the subject, guiding and expediting the work to its conclusion. She has made this an exciting adventure.

Through it all my patient husband, Donald Grubbs, suffered neglect, lent support, and cheered me on. He has a very grateful wife.

CONTENTS

INTRODUCTION

If you are interested in modeling portraits in clay, in capturing the likeness of a friend, relative, child, or for that matter, anyone at all, this book is for you. It is for the beginner and the more experienced sculptor. The newcomer to modeling in clay will find every detail he or she needs to know in order to model a head. If you're more experienced, I think you'll find an approach here that can be adapted easily to your own working methods and skills. I've developed the procedures explained in this book over a long period of time and believe that as you examine my approach, you will discover ways to enlarge your own visual vocabulary and enhance your artistic perceptions.

First, I suggest you read the book through and then return to study problems that have been especially puzzling to you in portraits you may have made in the past, or those in which you anticipate problems. Then find a cooperative friend or relative and begin at once to try out this method. Ask anyone who will give you a moment to look at your work and contribute observations. Each of us notices different details about the world around us. I find that taking into account the observations of others enriches the work and broadens my perceptions for the next job. Return frequently to the text and the photographs to review these techniques. But first, a word about how the book is organized.

Because it's important to have all the right materials, tools, and equipment at your fingertips before you ever model a head, the book begins with the items I recommend you assemble. Naturally, this includes a discussion of the various clays available and most suitable for portrait sculptures. The next chapter, *Working Methods*, is very impor-

tant for you to study closely, In this chapter, I outline in detail the procedures involved in modeling one portrait. In this instance, I used my son Richard as the subject, but it could have been anyone. The important thing to note in this chapter is that these are the procedures I follow, in the order I follow them. Thus, you'll find I make certain decisions before beginning a portrait, such as determining the scale in which the portrait will be made, and selecting the type of clay that seems most appropriate to use. These have an effect on the price of the work if it happens to be a commissioned piece. Photographing the sitter, taking measurements, scheduling sessions, and setting up the work space are all covered in detail, even before I get down to the really exciting task of setting up the head and developing the likeness.

In chapter 3, I demonstrate step-by-step how to model individual features—the eyes, nose, mouth, chin, ears, hair, and neck and shoulders. Obviously, when modeling a particular portrait, it's the individual variations in the basic shapes that help establish a successful likeness. However, it's also important to understand what general forms to look for while building each feature. In these mini-demonstrations, I offer guidance on how to observe the underlying structure of each of these features.

In chapter 4, I take a closer look at the special ways to capture your sitter's personality. There are lots of little tricks you can do to relax the sitter, pose him or her, as well as uncover characteristic attitudes, personality traits, and style. Learning some of these techniques will undoubtedly add vitality and credibility to the finished piece. I'm sure you'll discover many methods of your own for catching that characteristic smile, tilt of the head, and telling detail.

In chapter 5, I have selected six different models as my subjects. For each, I demonstrate how to model the head following the basic sequence outlined in chapter 2. Each subject in this chapter represents a different head type and therefore offers a good look at how I tackle a wide variety of portraits.

Chapter 6 is devoted to explaining all the steps involved in finishing the clay portrait. I demonstrate step-by-step how to hollow out the head, the procedures to follow for drying and firing the sculpture, and lastly, how to apply a patina before mounting the head for presentation.

Once you have studied all these chapters, get yourself set up, if you haven't already, and begin working. I cannot stress enough how important it is to practice. Practice, practice, and more practice will give you very satisfying results.

The best training I ever had was at the Fleischer Art Memorial in Philadelphia. There twice a week for three years, I set up a clay figure in two hours and then tore it down. Those sculptures were never cast. It was beginning again week after week that trained the eye and hand. At first, it was distressing to tear down the product of two hours of painstaking work. However, it gradually became apparent that the aim of an evening's effort was not to make an object, but rather to develop skills to keep building on. The excitement was in improving upon the efforts of the previous week, and in seeing just how much more I could accomplish. Finally, there was no regret at all in tearing down a figure. With all this practice, I acquired the confidence that something better would be possible with each new effort. This kind of conviction develops only with experience.

The more you practice, the more your eyes will be opened to further possibilities, and the deeper your perceptions and appreciation are bound to become. Your objectives will change and include dimensions of which you had not been formerly aware. Every head you make will be an adventure and an improvement over the previous one. Each time, your hands will "remember" more and your eyes will observe more. As you become more and more observant, so too will the whole process become more and more exciting.

One final point. Since this book is not intended to be an anatomy text, I will seldom refer to any muscles or bones by their anatomical names. If you want to learn more about these matters, there are several books which I recommend you study. These are listed in the bibliography at the back. Now let's turn our attention to modeling a likeness.

CHAPTER 1

MATERIALS, TOOLS, AND WORKSPACE

Before you ever model a head, it's important to have all the right materials, tools, and equipment at your fingertips. So, first let's review all the items I suggest you have before you—whether you intend to set yourself up in business as a portrait sculptor or are working for your own pleasure.

CLAYS

There are three basic types of clay that are useful for modeling: earthenware, stoneware, and porcelain. I will consider the properties of each of these clays and how they compare to each other. As you work with them, you may discover a preference for the effects you can achieve with one or another type of clay.

EARTHENWARE. Earthenware clays are coarse, low-fired clays with various impurities that cause interesting color variations. These may be used where rich dark brown, reddish-brown, or orange colors will add to the effect desired for the finished piece. Earthenware is relatively grainy to the touch, so it is especially good when roughly textured surfaces are desired. It also holds water well and has an open body that moves easily in response to pressure. This means it dries slowly and stays pliable for a long time, which is also helpful when modeling a piece over an extended period of time.

Earthenware cannot be fired at high temperatures because the clay will warp and often blister. If you want to use an earthenware clay, be sure to find out at what temperature it matures. The individual who will be firing your piece will need to know this information so as not to fire it

above that temperature. If you fire your own work, be sure to turn off the kiln before it reaches that temperature. The patina actually adheres better when the clay has not completely matured, that is, when it hasn't been allowed to reach its maximum hardness.

STONEWARE. Stoneware clays have a microscopic particle size somewhere between that of coarse earthenware and that of fine porcelain. Stoneware fires to colors ranging from buff to gray or white, but does not mature until a very high temperature is reached. There's no need to worry about the finish adhering as long as the person who fires your work puts it in the kiln only with pieces being bisque-fired (fired to a low temperature) and not with pieces that are being high-fired.

Stoneware clays remain pliable with a wide range of moisture content. Compared to porcelain clays, they can be wetter without being sticky and drier without tearing. Fine or coarse grog (crushed fired clay) and/or sand are often mixed into the clay. These additives contribute to the texture of the surface. As the clay heats up during firing, a chemical reaction takes place forming steam that must escape through the surface or into the already fired grog dispersed throughout the clay body. In this way, grog helps to protect the piece against exploding in the kiln. This is what is called a loose and open clay body.

PORCELAIN. Porcelain clays are composed of finer particles than earthenware or stoneware clays. And because the particles in porcelain are packed more tightly together, it is a smoother textured clay. When it has just the right amount of moisture, porcelain feels creamy and silky. When it's too dry, it gets stiff and crumbly; and when it's too wet, it gets sticky. So, it is particularly important to maintain just the right moisture content when working with such a fine clay. With porcelain there is a very narrow range between too wet and too dry. The best way to keep the clay wet is to spray it periodically with an atomizer or a plant sprayer. You'll learn by experience how to do this most effectively.

Porcelain fires to white or near white, providing a surface color that does not show through or alter the color of the patina that's applied. Some artists like to use a finish that is very close to white for young or dainty subjects. In these instances, the whiteness of porcelain can be used to advantage. Although porcelain has a tendency to warp or crack at high temperatures, this is not important for portrait sculptures since you will only be bisque firing. It is the perfect medium for a miniature portrait such as the one of *Tila Maria* (page 14).

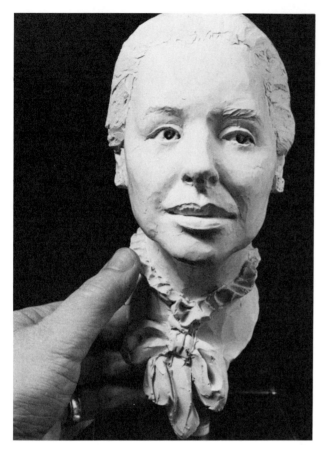

Tila Maria, bisque porcelain, 7"h x 4"w x 4"d, collection of Mr. and Mrs. William W. Hancock. Porcelain lends itself to small scale portraits, because of its smooth creamy texture and pale color.

Mrs. William Hancock (Photo courtesy Joe Barcia).

A life-size head is a rather large object to model in porcelain. You run into problems of sagging, stretching, and splitting. In the portrait of *Cindy* (page 32), which I executed in porcelain, the fired head is $\frac{7}{8}$ life size. I had to prop up the chin and shoulders with blocks of wood when modeling *Cindy*. Overnight the clay would sag around the edges of the blocks. I would push it up again in the morning and work as quickly as possible each day and many hours a day to cut down on the number of working days. When the modeling was finished, I dried the surface with a blow drier to stiffen the clay quickly for hollowing out. In spite of these precautions, there was a big dent under the chin when the piece was hollowed out. I corrected this by moistening the area and filling it in. It was an anxious time. As a result, whenever I use porcelain I purposely do not work more than $\frac{7}{8}$ life size.

If the portrait is to be large and rough in texture, I prefer to use a heavily grogged stoneware or earthenware. But I do find that people are drawn to porcelain. Its precious quality is appealing and they often are willing to pay more for it, which often makes the extra trouble of modeling in porcelain worthwhile. Porcelain is quite satisfactory for modeling tiny portraits five or six inches high. Naturally, this adds to the range of choices a sitter or client

has for a portrait, and, frankly, I enjoy the change of scale. Occasionally, changing from coarse clays to fine silky porcelain heightens your awareness of texture so that it becomes a more conscious part of the work.

CONDITIONING THE CLAY

Moist clay comes from the supplier ready to use. It generally has just the right moisture content to use with satisfaction. Consistency is even throughout the clay body; there are no lumps of drier clay and no soggy masses in the bottom of the bag. Occasionally, you'll get a package of clay that is too wet. If you do, slice it with a wire and spread it out to dry for a short while. The length of time required to bring it to optimum condition will depend upon how wet it is and also upon the humidity of the room in which you are drying the clay.

Once I bought a bag of porcelain that was too dry to cut. I had to leave the whole block in a bucket of water for several months, then slice it and knead it into condition.

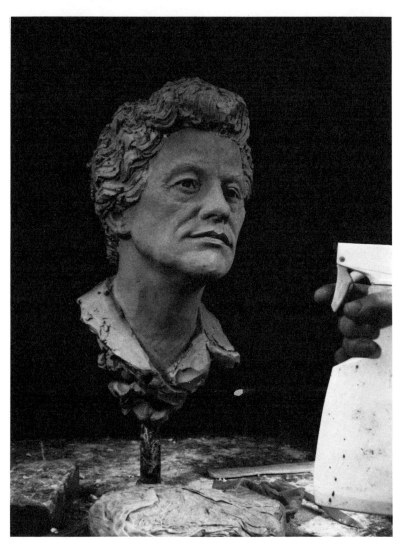

Here you see the kind of plastic spray bottle I use for moistening the work before it is covered with plastic.

I made this plaster batt by pouring a mixture of plaster of paris and water into a plastic lined cardboard box. Some wire coat hangers were submerged in the wet plaster for reinforcing rods. When clay is too wet, I spread it on this batt to dry. The plaster absorbs the moisture.

This clay is obviously too wet and is a nuisance to handle. It sticks to your hands and tools and slows up your progress.

This clay has the proper moisture content; you can cut it easily, leave a clear crisp surface, and it doesn't stick to your hands or tools.

This clay is too dry. It shows tearing marks and is difficult to push or cut into shape. It doesn't stick to tools and sometimes not even to the clay of the sculpture you want to add it to.

As you are working on a particular portrait, you want to make sure the clay stays in condition. Whenever you leave the work for more than half an hour, spray the piece with water. Do not spray it so much that the water runs down the face. Just lightly moisten the surface. Then cover the piece loosely with plastic. The plastic bags from your dry cleaning can be recycled for this purpose. Put scrap clay which accumulates around the base of the armature into a separate plastic bag, spray it, and close the bag with a wire twist tie so the clay can absorb the moisture. You can always add scraps of clay to this bag later on when you are hollowing out the head before firing, and condition these for reuse.

If you take a handful of clay out of the bag and find it is a little too stiff to work with, spray the clay in your hand and knead it until it is the right consistency. If the clay becomes too wet, the traditional procedure is to spread it out on a plaster batt. This dry plaster quickly absorbs the water out of the clay and soon it is ready to use again. You can make a plaster batt by pouring a mixture of plaster of paris and water into a flat cardboard box lined with plastic.

It's not a good idea to mix clays, because they expand and contract at different rates. This causes trouble in

firing, so you must be sure to clean one kind of clay off the batt before using it again to dry another clay. I use a shortcut and dry clay on a pad of old newspapers. Some people use old telephone directories for this purpose.

When clay is too wet, it is a nuisance to handle. It sticks to your hands and tools and slows your progress. When it is too dry, it tears and is difficult to push or cut into shape. Unlike clay that's too wet, it doesn't stick to your hands or tools or even the piece of sculpture that you're modeling. When clay has just the proper moisture content, it cuts evenly and crisply, responds to the pressure of your hand or modeling tool, and can be worked easily.

CAMERAS

A camera is an indispensable tool for the portrait sculptor. It's the one tool which makes it possible for you to work when your subject is not present. I use a 35mm camera fitted with a 55mm macro lens for close-up work and take photographs of the subject every 45 degrees around the head using black-and-white film. I refer to these photographs when working on the sculpture in the absence of the sitter.

When the work is finished, a camera comes in handy too, since the sculpture should be photographed to provide a permanent record of your progress. If you don't have a 35mm camera, an instant-picture camera will also do. You can use these just as well to take shots of the sitter from every angle, but the sharpness you can get with a 35mm is preferable for detailed close-ups. Cameras of other formats, such as $2\frac{1}{4}''$-square or 6×7 cameras would also be suitable. As your skill improves, I'd recommend purchasing a better camera. You'll find it's worth the investment since it's good to have professional quality photographs for your portfolio, for press releases, and even for registering copyright on your works. It's also a good idea to keep color slides of your work for submission to shows, galleries, and slide registries.

PHOTOGRAPHING THE FINISHED PORTRAIT

When photographing the finished portrait, you'll want to arrange the lights to create a full range of tonal values from deep shadow to highlight. This helps reinforce the three-dimensional quality of the head. In addition, the background should not be distracting. Plain black eliminates the problem of shadows cast by the sculpture onto the background. I use two yards of wide black felt that I hang on the studio wall, so I am always ready to photograph.

For special purposes you may want to photograph the sculpture *in situ*, especially in the case of a portrait that is installed in a public place.

There's usually one best angle from which to photograph any sculpture, the one that reveals the personality of the work most effectively. Be sure you have at least that photograph for publication and for your portfolio. In addition, you may also want to photograph the sculpture from other angles to use as reference material for future works. For registering your copyright on the work, you'll need a front and a back view, one of which shows the signature and the copyright date. Copyright photos should be 5" × 7" or 8" × 10" and printed on archival paper.

MAGNIFYING GLASS

A magnifying glass is particularly useful when you want to study details in the photographs while you're modeling the portrait. It enables you to see more clearly just how much of the upper lid shows when the eye is open, to see the

Here you see one of the 35mm cameras used to photograph both my subjects and their portraits. The magnifying glass is for studying the photographs closely. The calipers and ruler are for measuring the heads of the subjects as demonstrated in chapter 2.

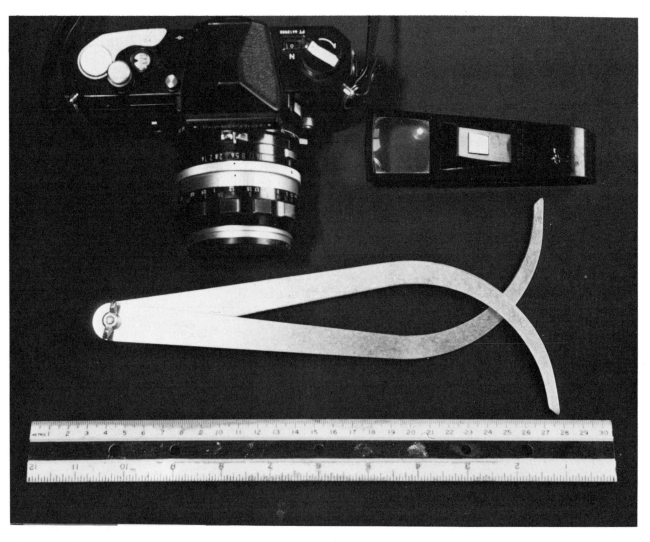

exact shape of the wings of the nose, the openings of the nostrils, and other details. It is very important for you to study these small curves carefully, for each one is important in helping to develop a likeness.

My magnifying glass has a little light that can be directed at the photograph while you study it. The light is helpful but not essential.

CALIPERS AND RULER

Calipers are used for measuring the subject's head. (How to use the calipers is demonstrated in detail in chapter 2.) With the ruler you measure the distance between the points of the calipers and then record these measurements on a measurement chart. As you can imagine, these tools are extremely helpful in establishing the perimeter of the portrait sculpture. They make it possible for you to check your work as you develop the portrait and give you instant feedback on whether or not any feature—chin, nose, ears—is either incorrectly placed or out of proportion.

MEASUREMENT CHART

In setting up a portrait, I have found that there are twenty basic measurements that are helpful in establishing the dimensions of the head. These measurements are all indicated as diagrams assembled on a handy chart, which you can make for yourself.

The first four measurements across the top row of the chart establish the length and breadth of the face. The next few measurements mark further points on the perimeter—such as the tip of the nose and the tip of the chin. These are followed by measurements of what one might call interior points—such as the edges of the eyes, mouth, and nose.

These measurements are the keys to checking whether you are maintaining the correct proportions. As you model the head, you check and recheck the actual dimensions of your sculpture against the measurements you've recorded on this chart.

I've developed and modified this chart over the years so that it presents a sequence of data that I use to set up the proportions of the sitter's head. Using this chart, I find I can work more efficiently than if I work by eye, and as a result, I have saved hours of modeling time. Obviously, it's difficult to make the measurements precise, but that's not necessary. It's possible to come fairly close, and that's all that's really required. The artist's observations of attitude, mannerism, mood, and expression are far more important to the finished portrait than mathematical precision.

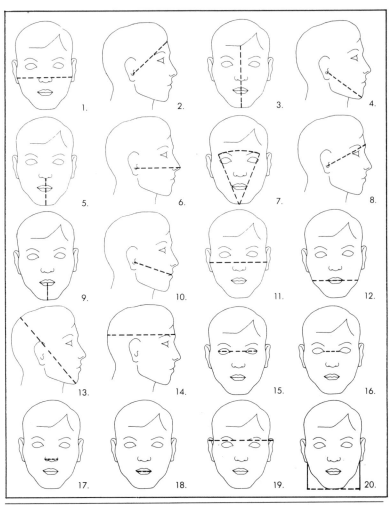

This is the chart with diagrams for the twenty basic head measurements, which you will use in modeling the portrait.

USING THE MEASUREMENT CHART

If the head is to be smaller or larger than life size, two copies of the chart are needed—one for the life-size dimensions and one for recording the reduced or enlarged measurements. A life-size adult head measures approximately 5″ ear to ear. Ninety percent of life size would be 4½″ between the ears, and eighty percent, which is my favorite size, would be 4″.

The chart showing the scale of measure to be used for the portrait can be taped on to a board along with the photographs used for modeling. These should be placed in easy view near your sculpture stand. In chapter 2 you'll learn more about just how to make these measurements and use them as you work.

CALCULATOR

It is unlikely, when modeling in clay, that you'll work larger than life size at first. I'd recommend working smaller than life size and using a hand calculator to help you reduce the measurements taken from life. A calculator makes the arithmetic simple and quick. If you are calculating eighty percent of life size, you punch the life-size measurement

into the calculator, hit the X button, and then the decimal point and then 8. Then touch the equal button and the answer will appear, which you will use on your reduced measurement chart. For example: $5 \times .8 = 4$.

Conversion Chart

This conversion chart can be used to convert fractions as measured on a foot ruler into decimals for your calculator, when you want to reduce life measurements to another scale.

$\frac{1}{8} = .125$

$\frac{1}{4} = .25$

$\frac{3}{8} = .375$

$\frac{1}{2} = .5$

$\frac{5}{8} = .625$

$\frac{3}{4} = .75$

$\frac{7}{8} = .875$

Examples:
1. *To find eighty percent of a life measurement of $4\frac{5}{8}$ inches, multiply 4.625 by .8 with your calculator to get the answer: 3.7 inches.*
2. *To find ninety percent of a life measurement of $2\frac{7}{8}$ inches, multiply 2.875 by .9 with your calculator to get the answer 2.5875. Round this off to 2.6 inches, since the measurements do not really have to be that precise.*

MODELING TOOLS

There is, as you've probably already discovered, a wonderful variety of commercial modeling tools made of boxwood, rosewood, brass, and other materials. There are wooden paddles of various shapes, wire loops, and thin strips of metal attached to handles. These latter tools are called ribbon tools, and I use them only for hollowing out a sculpture. You may like them for modeling as well.

The modeling process can be generally divided into two actions: adding on and cutting or taking away. The wire loop and ribbon tools are used principally for cutting away clay. The paddles are used for adding on. You should try many different tools to learn which ones suit your personal style and fit most comfortably in your hand.

I have come to use one commercial tool almost exclusively. You will see it in some of the photographs in this book. It fits nicely in my hand, has one round end, while the other end is pointed and nice for getting into small places. It has one straight edge and one curved. It seems to do just about any cutting or adding on of clay that I need. Once in a while it's a good idea to change to a larger tool and

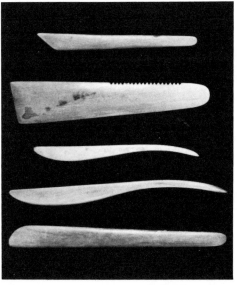

Here you see a collection of wooden paddle modeling tools. These can be used for adding clay on to the work, scooping it off, and the serrated one for making a textured surface.

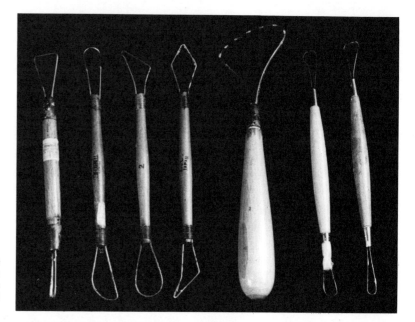

These tools are for cutting away excess clay. There are two types: the wire loop tools on the left and the ribbon tools on the right. Some of the wire loops have notches along one side of the wire which produce a scored surface texture.

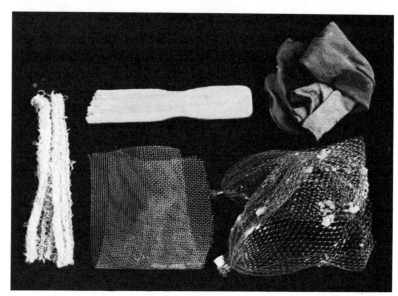

Here are some makeshift tools. Clockwise from the top: a paint paddle, nylon stocking, a string bag which was used for packaging onions, a piece of wire screen, a cheesecloth rag. All of these create interesting textures on the surface of the clay. Try experimenting with each to learn what effects you can achieve.

work in a rough sketchy way just to loosen up your technique.

For texturing the surfaces of the clay after the form is established, I often use a variety of found objects as modeling tools. These are makeshift tools which help achieve the effect I'm after.

A block of Styrofoam makes an efficient tool for the initial shaping of the principal masses of the sculpture. You can slap a large mass of clay with the side of the block and push it quickly into a general head shape uncluttered by any details. So the next time you buy something packed in Styrofoam forms, don't throw the Styrofoam away. Instead, cut off a piece about 2″ × 3″ × 8″ and use it as a tool for blocking in the shape. If that size is too big for you, cut it down until it is comfortable.

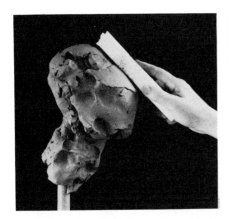

The Styrofoam block in this picture is being used to slap the clay into a basic head shape.

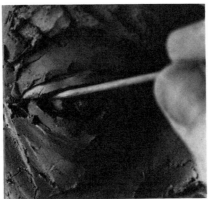

A toothpick is an excellent tool for pressing the whites of the eyes in behind the eyelids and also for scooping out the iris of the eye.

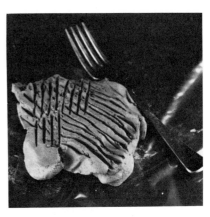

A dinner fork made these dark sharp parallel lines and also the very active crosshatched shadows in the upper left.

A piece of wire screen can be used to level an area and give it a light-catching surface at the same time.

The very finely textured area you see in the middle of the shiny surface of this lump of clay is made by pressing one layer of nylon stocking onto the clay with the flat side of a wooden modeling tool.

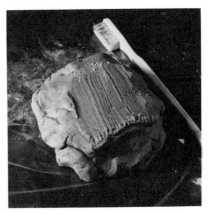

These fine lines were made with a toothbrush. A larger stiff brush, such as a whisk broom, would produce a coarser pattern.

I also find toothpicks indispensable for forming eyes. Even a dinner fork can be used to create a very exciting surface texture active with light and shadow contrast. Other household items that have come in handy include a grapefruit knife, a toothbrush, and a paintbrush.

I used to buy tongue depressors by the gross at the drugstore to use as disposable modeling tools. They were convenient to carry to class, made a crisp impression on the clay, but I did find that they got soggy and wore out too quickly. On the other hand, I have found the old-fashioned wooden paint paddles to be excellent modeling tools. A paint paddle broken in two has a jagged edge that can also be used to create the textural effect of hair.

A scrap of wire screen is useful for leveling out the surface of a plane without leaving it slick or lacking in textural interest. A piece of nylon stocking creates an extremely fine skin texture, one I would recommend using for a child's portrait. Simply press one thickness of stocking gently against the clay over the whole skin area. Also,

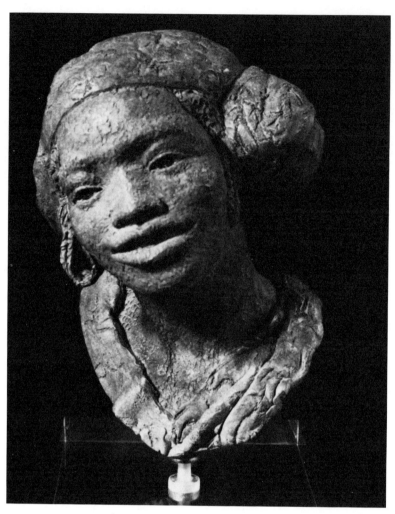

Girl with Pointed Teeth, bisque porcelain, 13"h x 6½"w x 6½"d, collection of the artist. The texture of this girl's scarf and collar was made by pressing bunches of a back-packer's string hammock onto the clay.

I've found that a stiff brush is one of many tools you can use to create highlights on surfaces such as clothing or hair.

Wherever you go, I urge you to keep an eye out for objects that will help increase your vocabulary of modeling techniques. By all means experiment with lots of tools. You'll be surprised at the variety of effects you can achieve with a host of materials you have right in your own home.

HOLLOWING-OUT TOOLS

Eventually, you must hollow out the portrait before firing it. It would be possible to fire your portrait solid if it didn't have an armature inside, if you had endless time for it to dry thoroughly, and if you were patient enough to fire it extremely slowly. I'm sure you'll find that it's much easier to build the head on an armature and hollow it out afterwards. To do so, you'll need a wire with two handles to slice off the back of the head and a ribbon tool, which is the primary tool for digging out the clay from inside the head. I find it easier to use the tool with a narrow ribbon of steel forming a loop than the kind with a loop of wire. The latter is not as sharp and tends to drag the clay.

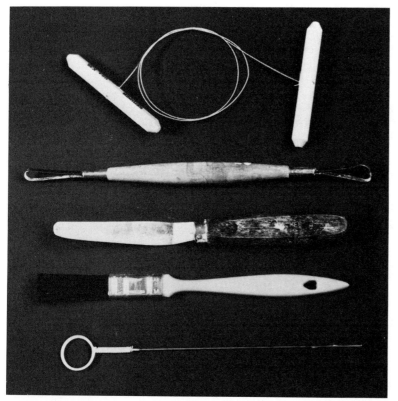

These are tools used for hollowing out a head. The wire with two handles is for slicing off the top of the head. The ribbon tool is for scooping out the clay; the palette knife for scoring the cut edges; the brush for wetting the edges so they will bond; and the cake tester for piercing holes part way through thick places in the clay to allow moisture to escape.

A cake tester is useful for poking holes on the inside of the sculpture to provide channels for steam to escape during firing. A palette knife is also used for scoring the cut surface of the head prior to reassembly, and a small paintbrush can be used to wet the edges of the cut surface to facilitate bonding after reassembly (a complete discussion of how to hollow out the head before firing is given in chapter 6).

ARMATURES

An armature is like a skeleton; it provides the support for the clay. There are commercial ones available such as the one shown here. This type of armature is designed for clay heads that will be cast in plaster. There is one problem with using them for heads that will be hollowed out for firing. As you can see, the cluster of wire that forms the top of the armature makes it difficult to hollow the head out easily. And it is not possible to remove pieces of the armature as they are uncovered when the clay is dug out from inside the head. Therefore, I build my own armatures which are designed to solve these problems. I think you'll find them very easy to make using a handsaw, drill, and screwdriver. You'll need to buy just a few items:

1. *one piece of $\frac{3}{4}''$ plywood cut 18'' square*
2. *two 18'' strips of 1'' × 1'' or 1'' × 2'' wood*
3. *four $1\frac{1}{4}''$ screws*

This is a commercial head armature. You can buy it in several sizes depending upon what size head you want to make; however, it is designed primarily for work to be cast in plaster. If you intend to hollow out and fire your work as I demonstrate in this book, do not buy this type of armature.

4. *four ¾″ screws*
5. *one floor collar for ½″ diameter (interior dimension) galvanized pipe*
6. *one 90° elbow for ½″ pipe*
7. *one 45° elbow for ½″ pipe*
8. *three lengths of ½″ pipe (6″, 3″ and 2½″ long)*
9. *a small jar of Vaseline*

The procedure for making the armature is as follows: (1) Set the good (smooth) side of the plywood face down, and place the two strips of 1″ × 1″ wood on top parallel to each other and several inches in from each side. (2) Drill two holes through each strip and part way into the plywood. (3) Insert the 1¼″ screws in these four holes and fasten the strips to the plywood. (4) Turn the plywood over with the strips on the bottom. You'll see that you can slide your fingers under the edges of the plywood to lift it. (5) Now, center the floor collar on the top of the plywood and, using a pencil, mark the plywood through the four holes in the collar. Set the collar aside. (6) Drill holes where the marks are; put the collar back in place, and fasten it down with the four ¾″ screws. (7) Now grease the threads of all three

BUILDING AN ARMATURE

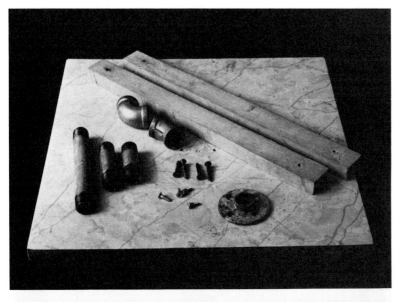

Step 1. These are the items you will need to assemble to build your own armature: plywood, screws, a floor collar, elbows, and pipes.

Step 2. Place the two wooden strips on the bottom of the plywood, parallel to each other and several inches in from each side. Then drill and screw these strips on with 1¼" screws.

Step 3. Find the center of the armature base by drawing lines diagonally from corner to corner. Here the locations of the screw holes are being marked.

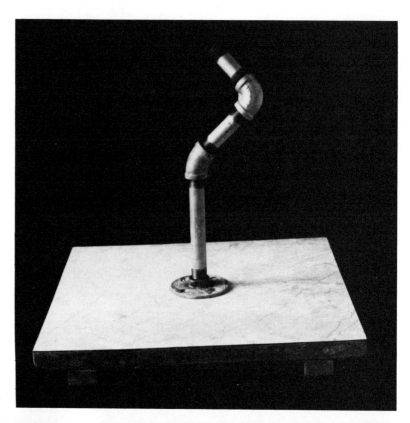

Step 4. Screw the pipes together in this manner to complete the armature.

If you are making a small child's head on a small scale, you may eliminate the middle pipe and replace it with the shorter pipe which was on top.

Here is a simple armature for a miniature head like the one I did of Mrs. Hancock (*Tila Maria*). The collar and pipe are smaller in diameter as you can see by comparison with the pieces of pipe from the large armature.

pipes with Vaseline to prevent them from rusting and screw them together with the elbows.

Each time you finish using this armature, take the pipes apart so they don't rust together and remember to grease them with Vaseline before you reassemble them.

This armature is good if you are making an adult head from eighty percent of life size up to life size. If you are going to model shoulders and part of the chest, replace the 6″ pipe with a 10″ one. For a small child's head eighty percent of life size, put the 2½″ pipe between the two elbows and eliminate the 3″ pipe. For a really tiny head, you will have to make a special armature with a smaller floor collar and one thin vertical pipe.

TURNTABLE

A plastic turntable about 10½″ in diameter found in the kitchenware section of the drug or department store and available at a reasonable price does an adequate job of holding and turning the weight of an armature with a base 18″ in diameter and about 25 pounds of clay. This type of turntable can be used on the kitchen table or on the workbench. You can vary your point of view of the sculpture by crouching down near the floor and looking up, or working seated or working standing up. It is also possible to insert blocks or a stool under the turntable to adjust the height of the sculpture. But, I think you'll find that this quickly becomes tiresome and before long, you'll want to buy a sculpture stand.

Here you see the top and the bottom of some plastic turntables my students use when working seated around a table.

SCULPTURE STAND

The primary advantage of a sculpture stand is that you can adjust its height. If you ever have the opportunity to observe a class of students sitting around a table each modeling a head, you may notice that most of the heads are looking up at their creators. This is because the students

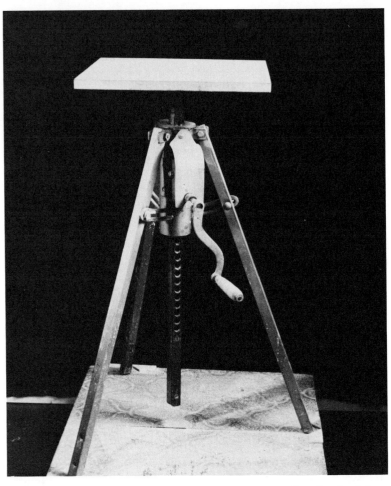

This is a very nice sculpture stand. The top cranks up and down. It can spin around, or you can tighten a thumb screw to keep it from turning. You can remove the top and fold the legs together for carrying it.

have been working most of the time at one level—looking down upon their work.

An upward gaze can be a legitimate pose, but it is not always the most appropriate. Thus, it's really best to have a sculpture stand and enjoy the flexibility of viewing the work at any level.

Less expensive sculpture stands are adjusted by inserting a pin through holes in the telescoping central shaft. Although this is sturdy enough, the work must be lifted off the stand every time an adjustment is made. This is obviously a disadvantage especially if the piece weighs 25 pounds or more. The effort required tends to discourage many artists from changing their point of view often enough.

If you can afford it, a stand with a crank adjustment is well worth the difference in price. Since this stand will be your biggest investment and will last virtually forever, you are unlikely to want to replace it. I'd suggest you buy the best you can the first time. I have mounted my stand on a rolling platform so I can push it nearer the mirror or over to the window to see the work in a different light. The stand came with casters, but they were not engineered properly

and did not roll freely. Whatever you do, don't buy the stand with telescoping legs! I had one once and it was a constant annoyance—never level.

KILN

Most beginners will not have a kiln, but it's easy enough to find someone else to fire your work. The Yellow Pages of the phone book will list ceramic studios that will fire for a charge determined by the number of cubic inches your piece occupies. You might also try an art school or art department of a school near you, a potter's guild, or an individual potter. You can figure the number of cubic inches by multiplying the tallest part of the portrait by its widest measurement and its longest measurement from front to back. This is an estimate of how much space it will occupy in the kiln.

For a long time it was cheaper for me to pay others to do my firing. In recent years I have had so much work to fire and so many deadlines to meet that it's become less expensive and more convenient to have a kiln in my studio. I bought the smallest one I could find. It measures $14\frac{3}{8}''$ in diameter and is $13\frac{1}{4}''$ deep inside the firing chamber. It holds half a dozen tiny heads, two children's heads eighty percent life size, or one adult head just under life size if the shoulder section is not too wide. With the addition of an extension ring $6\frac{1}{2}''$ high, it holds one life size head with collar, part of the shoulders, and some of the chest included. If I make something larger, then I have to find a friend who has a larger kiln.

There are many manufacturers of kilns of various types and sizes, both electric and gas-fired. The larger the kiln, the more work you will have to produce to have a full load. I often have to fire just one piece to meet a deadline for a commission, so the small kiln is ideal. A gas kiln requires the installation of a gas line. An electric one requires a 220-volt line, which many houses already have. It's easier to unplug an electric kiln and move to a new house than it is to have a plumber come and disconnect a gas one if you move.

PATINA TOOLS AND SUPPLIES

Fired clay is porous and absorbs dirt, which does not come off, so the surface must be sealed. At the same time color, which helps draw attention to the form, can be applied to the surface in a variety of ways. To make a patina, you'll need just a few items: shellac and alcohol for the sealer coat, and paste wax and powdered pigments for the top coats of color. Round sash brushes are used for applying the finish.

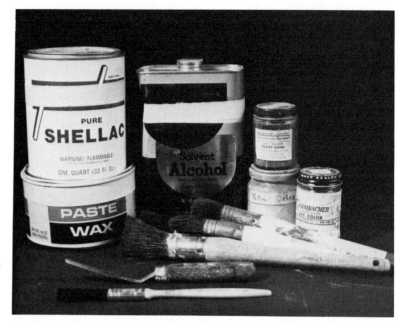

(right) Here are tools and materials for the type of patina I generally use: shellac and alcohol for a sealer, wax for subsequent coats, dry pigments for coloring the shellac and the wax, and brushes for applying the finish.

(below) *Cindy*, bisque porcelain, 14"h x 8"w x 8"d, collection of Urs, artist-potter. This very pale patina is a mixture of a half cup (4 oz) of table cream with a few grains of yellow ochre and burnt sienna dry pigment rubbed on the piece with a lint-free rag.

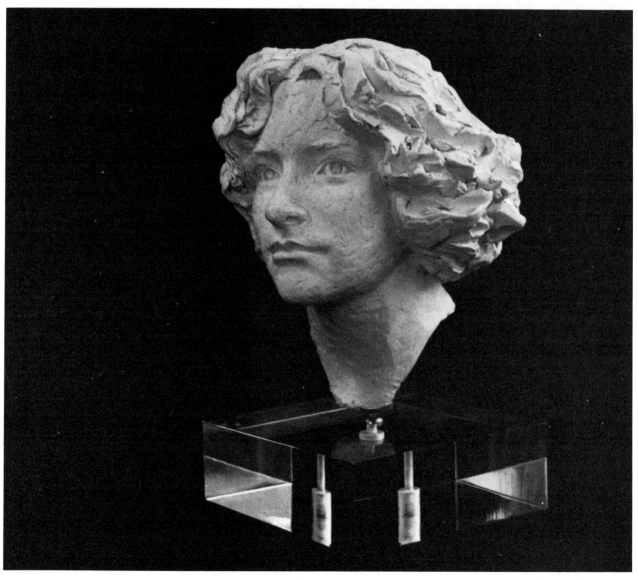

There are many possibilities for finishing a portrait, so enjoy experimenting with all the powdered pigments in various combinations (see chapter 6 for more details about making and applying patinas).

STUDIO SPACE

When choosing a work space, it's important to consider how far away from the work you'll be able to move to criticize it as the modeling proceeds. You'll be amazed at how the appearance of the piece changes as you move further away. Often, by concentrating on the minute details, you lose track of the whole effect. Stepping back to look at it from time to time helps you review what you've done thus far.

If the only space available to you is small, it would be helpful to install a mirror on the wall opposite the sculpture stand to double the distance for viewing the work. The mirror has an added advantage. You can turn the sculpture to look at it from all angles while looking in the mirror, whereas, if you must walk to the far end of the room to view the work, you must walk back and forth each time you want to turn the stand to see it at a different angle. In addition, you should go to the far end of the next room and look back through the doorway of your studio for a long distance view of the head.

You'll need space in your studio for a bench or tabletop within reach of the sculpture stand on which to put your bag of clay and all your tools. There must be room for a light easel to hold your picture board and room for your sitter or other people to walk around. You'll need wall space for a mirror and places to put finished work and pieces waiting to be fired. These are minimal requirements.

Here's my workbench with its accumulation of tools. The front of the bench top is cleared, fresh paper spread, the bag of clay at hand, armature ready on the sculpture stand, picture board in place, and a stool ready for the subject.

Here you can see how I use my bookcases as a display shelf. There are two long shelves on the wall for miniatures. You can also see the row of fluorescent lights along the ceiling.

MY STUDIO

I have an eight foot industrial workbench with shelves above it, which are filled with tools and lots of useful junk. Clays are stored in plastic bags below the bench, and the sculpture stand is usually beside the bench within easy reach of both the clay and the tools. To me it feels like a snug little nest with all my tools and materials at hand.

A row of bookcases contains art books and the kinds of things people usually put in desk drawers. The tops of the cases are used for display. I also have a drawing table, which is more often used as a desk. Another corner near the windows is reserved for photographing my subjects and the finished works. I also have a black felt backdrop in place, so I'm always ready to photograph.

When groups come to visit my studio for a talk and demonstration, there is enough space for us to sit in a circle and have a discussion. Sometimes it's a little crowded but everyone can see and hear what is going on.

Along the wall across from the bookcases is a homemade flat file with a bench top. Among other items stored here are the unassembled boxes used for packing very small

sculptures. Publicity materials are stored here along with anything else that's flat and too big for the file. There is a legal size, two-drawer file under this bench top as well. This file is a very important part of the business. If I didn't have a regular place where each piece of information could be dropped quickly as it comes to the studio, I would waste a great deal of time searching for addresses, bills, photographs, and other papers. The top of this bench is used for assembling boxes and packing sculpture, laying out picture boards, mounting sculpture, setting pieces to dry, and other work that requires some room for spreading out. When I hold a workshop in the studio this bench accommodates several people. So you see, the space and the furniture serve many purposes.

LIGHTS

Lighting the studio for sculpture presents an entirely different problem from that of lighting the painting studio. Form is the primary concern, rather than color. To photograph the sitter, side lighting is desirable. The shadows cast bring out the forms of the head. Modeling the clay, on the other hand, requires good light all around the modeling stand, so that you're never working in the dark.

My studio has a white ceiling and white walls. A row of fluorescent lights along two sides of the ceiling distributes the light fairly evenly. It is possible to turn off either bank of lights for side lighting. A row of windows across the north wall provides light from one side during the day if overhead lights are turned off. This daylight is best for taking the photographs from which I work between sit-

This corner is set up for photographing both the subject and the work. The piece of black felt hanging on the wall makes a good background and the window provides good light for daytime work.

tings. In addition, I use photo floodlights when the modeling is finished to check the shapes of the curves. It draws attention to harsh or unsuitably angular shadows, discontinuous changes of planes in the face, inconsistent textures, or other flaws that may go undetected in softer, more diffuse light.

FURNITURE

In a studio used for portrait commissions, there should be provision for seating visitors. I recommend comfortable folding chairs for guests and a high stool for the sitter—an industrial stool with back support is great. You'll be working standing up so you can move around the work freely, and so you can get your whole body into the action. Your sitter should be at about the same eye level as you are, but should have the choice of being able to sit down.

Children like to have some clay to play with while their portraits are being done. I put them on a high stool and give them a high pedestal to work on. This keeps them in one place and up high enough so that I can study their features. Children of all ages will remain engrossed in modeling clay for hours. Adults are generally so fascinated by watching the portrait develop that they need no other entertainment. They usually stand and watch, occasionally walk around the studio to look at other things, and sit only when they get tired. I do not ask the sitter to maintain a fixed pose, except momentarily when I want to observe a particular feature or posture.

Making a portrait sculpture is not like painting a portrait. You have to think in the round, see in the round, walk

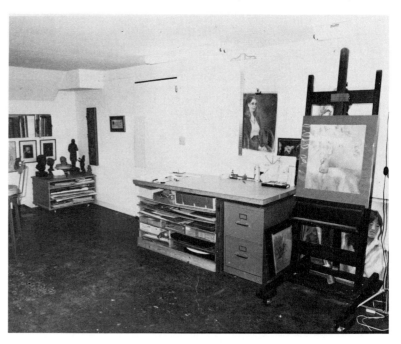

Here you see more bench space, the filing cabinet, flat files, and another small bookshelf under the stairs. Every nook and cranny is put to use in my studio.

around, and observe the subject moving around. There are at least 360 portraits you are making all at once. When you alter one view, you alter many others. Only by observing your subject in motion can you learn which attitudes are characteristic. Then you might ask for that pose to be held for a few moments while you check a particular tilt of the head or stretch of the neck. For this reason, you'll need space around the furniture for the subject to move.

CHAPTER 2

WORKING METHODS
MODELING A TYPICAL HEAD STEP-BY-STEP: PORTRAIT OF RICHARD

In this chapter I will demonstrate and explain every important stage in modeling a portrait sculpture. This process begins with the first meeting with the client, before you add the first pieces of clay to the armature. I will demonstrate the procedure I use, in the order that I have established as most efficient when working from photographs and the live model, by modeling in detail and step-by-step a portrait of my son Richard, a young flier.

DECIDING ON SCALE

Before you begin a portrait there are several things to consider. First you must decide on the scale of the portrait. How big or how small should it be? The answer to this will depend on a few things. First, consider where the work will be displayed. If it will be displayed in a public room with a twenty foot ceiling, a scale of life size or a little larger is appropriate. If it will be placed in a room with an eight or ten foot ceiling, the scale should be no larger than ninety percent life size. The reason is that a small head is lost in a large room, and a life-size head seems larger than life in an intimate space. A miniature head six or eight inches high is suitable for a table or bookcase in an average living room.

Second, consider the age of the subject. A child's head is larger in proportion to his or her body than an adult's. But when the work consists of just the head, the viewer does not have the size of the body to use as a reference to reinforce the impression of youth. For this reason I prefer to do a young child in a somewhat smaller scale, sixty to eighty percent of life size.

Third, if you are working on a commission consider the price your client is willing or able to pay. Offering a smaller

size at a lower price makes it possible to reach a larger market. Some will order the smaller size because that is what they prefer and others because that is what they can afford.

For this portrait of Richard I decided on a scale of eighty percent of life size. I like this size because it doesn't take up as much space as ninety percent life size but it is still large enough that the details are easy to model.

DECIDING ON THE TYPE OF CLAY

The decision about what kind of clay to use also affects the price. I charge twice as much for a portrait in porcelain as for one in stoneware or earthenware clay, primarily because the porcelain is more difficult to handle. The price of each of the clays is about the same.

Once the type of clay is selected, I choose a particular clay within that type on the basis of what its color will be when fired. I prefer to use a white stoneware clay in most cases, because it provides a neutral surface on which to apply the patina. Sometimes I use an earthenware that fires to red or brown, because it enriches the color of a dark finish.

For this demonstration I have chosen a white stoneware clay partly because it shows up well in the photographs and also because it will not affect the color of the finish.

BUSINESS DETAILS

The size of the piece and the type of clay determine the price. When these decisions have been made I ask for a deposit of twenty-five percent of the price. After the modeling is complete and the client has given permission to fire, the second payment of twenty-five percent is made. The balance is paid on delivery of the finished piece. The price includes mounting the portrait on a Formica or Plexiglas base. If the client prefers a stone base, there is an additional charge that depends on the prices from my supplier.

When the piece is cast in bronze the foundry takes care of the stone cutting and mounting, so I don't have to worry about it.

PHOTOGRAPHING THE SITTER

Once the business details are agreed upon, you can proceed to take photographs. The clearest and most useful pictures are those taken with a 35mm camera (or other high-quality camera) with black-and-white film. Form is what you are interested in, not color. I use a 55mm macro lens that makes it possible to get close enough to photograph just

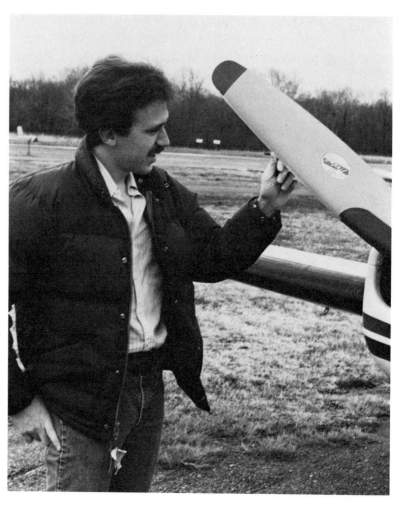

Richard, a candid photograph.

one feature if that seems desirable. When photographing your sitter, try to keep the camera at the level of the subject's eyes. Take one photograph full face that shows both ears equally. If the ears are covered with hair, guess. The point is to get a good idea of how wide the face is compared to its length. If the camera is well centered in front of the face, you can see how nearly symmetrical the face is and in which ways it is not symmetrical. As you know, faces are not perfectly symmetrical and the deviation is an important part of the likeness.

Photograph each side of the head trying to get a level side view of the nose, mouth, and chin. Take a picture of the back of the head to record the general shape and volume of the hair, the pattern of waves or curls, the length of the hair, and any cowlick.

All of these photographs should be made with the camera close enough so that the head nearly fills the frame of the picture, but not so close that you cut off any part of the profile. Using this approach you will be recording useful, large, sharp details for reference when modeling the head in the subject's absence.

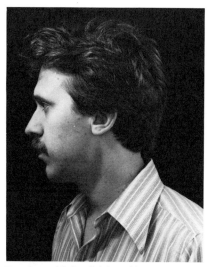

A photograph of the front view helps me see the general shape of the face—is it square, round, oval or heart-shaped? The front view is very important. In posing the full face, be sure the ears show about the same amount on both sides. That way you can judge if you are squarely in front of the person and seeing the full front of the face. If hair covers the ears, guess.

Richard's right side offers excellent detail of his entire profile. It is essential to be able to see an accurate side view of the nose, the relative positions of the upper and lower lips and the chin beneath, the curve between the root of the nose and the brow, and the shape of the forehead.

This photo of Richard's left profile is not quite as informative for the area around the mouth as the photo of the right profile, but it is still useful. It is nice to have a photograph of each side to look at when you are working so that you do not have to transpose the curves in your mind. The two sides are not exactly alike anyway.

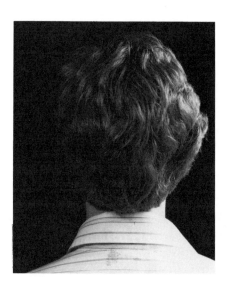

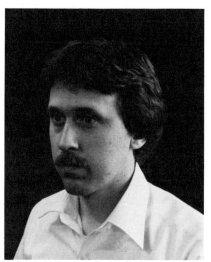

The back view of Richard's head is of value in designing the hair. You can see the pattern of growth and the length of hair as well as its relationship to the collar.

In this left, three-quarter view of Richard's head, you get some idea of the curve of the back and the relationship of the chest to the position of the head.

This three-quarter view of the right side shows the slope of the shoulders. You will find many important details in every picture as you study each one carefully.

Next, move the camera back a little to include the head and shoulders; first, a front view with the head turned 45 degrees to the right and then to the left. Add to these a view of either or both sides. These pictures will show the relationship of the head to the body, the slope of the shoulders, and the curve of the backbone. They will also show another view of the cheekbone and brow line from each side.

For these photographs I generally seat my subject next to a window so that the light from the window falls on one side of the subject and the light from a 75-watt photoflood lamp falls on the other side. In my studio the lamp is brighter than the daylight and creates shadows which bring out the form. Light that obliterates all shadows will not give the information you need. Much data can be gleaned from photographs, but it is important to remember that the camera lens distorts, especially at close range.

In the side views of Richard you can see how far his wavy hair falls forward of his forehead. You can see the angle his moustache makes with the lower edge of his nose, and just where his Adam's apple juts out from his neck. Look at the front view to see the pattern of hairs in the moustache and the eyebrows, how much of the upper lip shows under the moustache, and many other details. In the back view you can see the length of his hair and its relationship to his collar as well as the pattern of hair growth.

After I have taken all my photographs of the sitter, I'm ready to begin taking measurements.

TAKING MEASUREMENTS

It would be possible to make a portrait without taking measurements of the subject's head. By eye you would judge the proportions of the head and the size and placement of the features. However, you can save a lot of time by measuring the width of the head, setting up a clay form that wide, and then building the form to a measured length. If you place the features on that form according to your measurements instead of judging by eye, you will not have to move the nose because you have not allowed enough space between it and the chin for the mouth, or lower the eyebrows because the nose appears to be too long. By measuring how far up from the bottom of the chin the other features belong, you can place them accurately right from the start. Then after you have gone to the trouble of building a feature, you won't have to tear it down and rebuild it slightly higher, lower, or to one side.

Most beginners are inclined to increase the size of the head as the modeling progresses, adding on more forehead

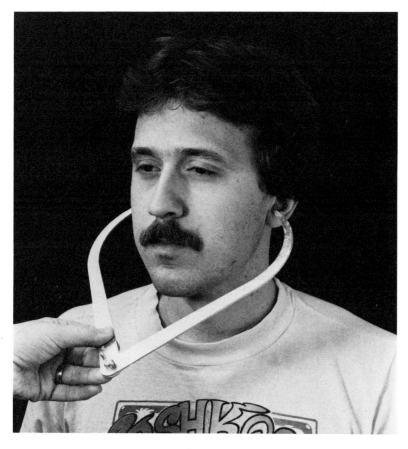

Here you can see I'm taking the first measurement. The calipers are set lightly with one point in each ear. I tighten the nut in this position.

because it seems to recede too far, then adding more chin to balance the forehead, and then more nose because that no longer seems long enough. If you build the head according to your measurements, it is possible to check whether adding to the forehead or taking away from the chin is the proper way to adjust their relationship.

The measurements are also used as a base for establishing scale. They can be enlarged or reduced, and you can check periodically to see that the scale has not been violated. If the scale is to be altered, the reduced or enlarged numbers should be indicated on a fresh copy of the chart so that only one set of numbers is before you when you work.

On page 47 are the diagrams I use to indicate the twenty measurements required for setting up a head. The first four measurements (from top left to top right) must be coordinated with each other before going on to the rest. These four establish the attitude, the tilt of the head up or down and to left or right. Once these are coordinated, the others, which place the features on the face, can be marked.

The measurements are not precise. Reduction or enlargement results in the magnification of error. The further from life size the scale, the greater the magnification of error. However, since the purpose is not to produce a

To gauge the measurement, I set the calipers on a ruler to find out the width of Richard's head at the level of the ears. It measures 5⅞". Now I proceed to take all of Richard's measurements and record them on the measurement chart.

computerized reproduction of a head, but rather an artistic interpretation, the measurements simply save time at the early stage of establishing the basic shapes.

First, you measure the width of the face from ear to ear, then its length from hairline to the bottom of the chin, and the distance from the hairline and from the chin to the ear. Next, you measure the distance from the bottom of the chin up to each of the features and then the width of these features. Finally, you measure the width of the neck. You could add other measurements if you like, but I find these twenty are enough to get the modeling off to a good start. As noted on Richard's measurement chart (100 percent scale), it does not matter exactly where you set the calipers, as long as you use the same place on the ear or the corners of the mouth every time you take that measurement. The numbers on the 100 percent chart are expressed in fractions, because I use a ruler marked in inches. I convert these fraction to decimals when I use a calculator to change the scale.

If you look at the chart showing Richard's measurements and compare these with a list of your own measurements, you will find that the variation from one adult head to another is surprisingly small.

To measure your subject's head set the points of the calipers on the locations indicated by the diagrams, tighten the wing nut of the calipers, and set the points against a ruler. Then record these measurements directly on your chart for easy reference. If the head is to be eighty percent life size, calculate the reduction and mark those measurements on a fresh copy of the chart. (Complete instructions on how to take all twenty measurements are provided next to the Measurement Chart pictured on page 47.)

SCHEDULING SESSIONS

After an agreement has been made for a portrait of a specific size, I explain to the client that three visits to the studio will be required. I hesitate to call them sittings because that implies sitting still, so I'll call them sessions. At this time we set up the calendar for all three sessions. The first will last about half an hour and will be devoted solely to taking photographs and measurements. I like to schedule the second visit at least two weeks after the first and the third a few days later. The second and third sessions will each last two or three hours and will be spent modeling the portrait from life. Occasionally, a fourth session is added. You may find that more sessions of shorter duration will suit your style better. You will discover what you prefer pretty quickly.

THE PHOTOGRAPHING SESSION

Before the subject arrives I set up the photographic equipment. I place a stool in front of the black felt backdrop on the wall, attach the camera to the tripod, set up the lights, lay out a measurement chart, ruler, calipers, and pen on my drawing table. If the portrait is to be a rush job, I load the Polaroid camera in order to be able to start work at once before the black-and-white film is processed. Have the photos enlarged to $3\frac{1}{2}''\times 5''$ or larger.

When the subject arrives I take the photographs first. Being photographed is a familiar experience to most people and sets them at ease. By the time we get to measuring we are a little better acquainted and even the children don't object to having their eyes measured. I put the calipers on my own face first to show what I intend to measure, and I ask them to close their eyes while I measure theirs.

All this is arranged as efficiently as possible and the visit is over in half an hour. The studio is no longer a strange place, the session has not been tiring and the subject departs looking forward to the next time.

SETTING UP THE WORK SPACE

On a piece of Masonite board about $24''\times 30''$, mount all the available pictures with masking tape. On the left, put the photographs of the subject facing toward the right, in the center the full face, and on the right side of the board, mount the pictures of the subject facing left. In between place the views of the head turned slightly to the side. It may be necessary to have two or more rows of pictures. The view of the back of the head goes at the bottom, flanked by any rear or side views. Put up the measurement

Measurement Chart

1. Set the points of the calipers lightly in each ear at the bottom of the hollow. The exact location is not important as long as it is the same every time.

2. One point of the calipers is placed in the same part of the hollow of one ear as that used in Figure 1. The other point is placed at the hairline (the root of the hair) in the middle of the forehead.

3. One point of the calipers is placed at the hairline, the other at the bottom of the chin to measure the length of the face.

4. One point of the calipers is placed at the same spot at the bottom of the chin and the other at the part of the ear hollow you are using as your base point.

5. Again set one point at the same spot at the bottom of the chin and the other at the bottom of the nose where it meets the front of the face (not at the tip of the nose).

6. Set one point at the base position in the ear and the other at the tip of the nose.

7. Set one point at the bottom of the chin and, using the other point, draw an arc across the brow. This measurement remains fairly constant.

8. Set one point in the ear again and the other at the middle of the brow line above the nose.

9. Set one point at the bottom of the chin and the other between the lips at the center of the mouth.

10. Set one point in the ear and the other at the center of the mouth between the lips.

11. Measure the widest part of the cheekbones.

12. Measure the widest part of the jawline.

13. Set one point at the bottom of the chin and the other at the top of the back of the head, to measure the long diagonal.

14. Set one point at the center of the brow line and the other at the center of the back of the head, to measure the greatest depth of the head.

15. Set one point at the outer corner of each eye. The subject is usually more comfortable with closed eyes for this step and the next one.

16. Set one point at the inner corner of each eye to measure the distance between the eyes.

17. Measure the width of the nose at its widest dimension.

18. Measure the width of the mouth from corner to corner.

19. Measure the distance from the tip of one ear to the tip of the other ear.

20. Measure the width of the neck just below the level of the chin.

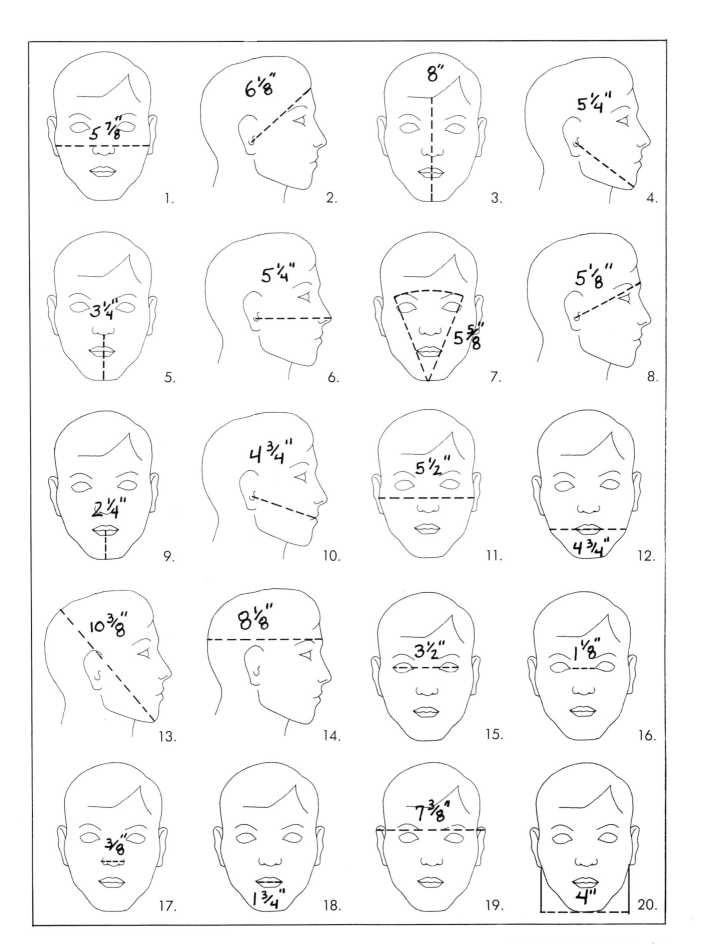

1.

2.

3.

4.

5.

6.

7.

8.

9.

10.

11.

12.

13.

14.

15.

16.

17.

18.

19.

20.

chart with the numbers for the chosen scale also and any notes about collar design or jewelry that you want to remember to use. Put this board close to the sculpture stand where you can easily see it. I put mine on a light easel at my eye level.

I have a high stool nearby for an adult subject to rest on and I work standing up. If the subject is a child, I set out a block of clay, for the child to play with, on top of a pedestal in front of the high stool. To the right of the sculpture stand, if you are right-handed, you will need a handy place on which to put your supply of clay and your tools. I use my workbench for this purpose. This is the bench where I will later hollow out the head, apply the patina, and prepare the head for mounting.

SETTING UP THE BASIC SHAPE

Once I have recorded the sitter's measurements and converted them to the scale we have agreed upon, I'm ready to begin setting up the basic shape. Now I'll show you how to

I'm ready to set up the work space. Here you see the picture board pulled as close as possible to the sculpture stand, the armature and tools assembled, and the clay on the bench within easy reach.

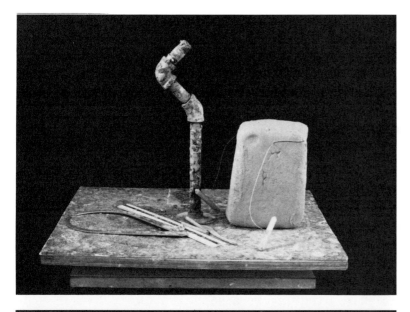

I assemble the armature and keep the calipers, ruler, modeling tool, and two dowels to mark the ears out and ready to use. You can see how the block of clay will be sliced by the wire.

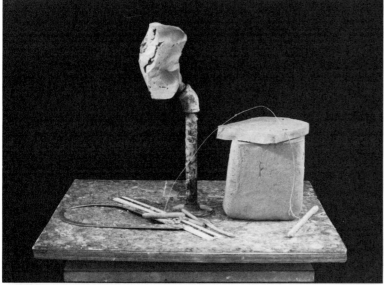

First, I slap a thick slab of clay onto the front of the armature, making sure that the face is built well forward of the pipes so that when I dig out the eyes there's no chance of exposing the pipe or even coming within ½" of it.

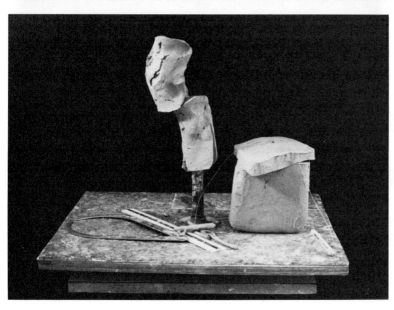

Next, I put a thick slice of clay around the lower pipe to mark the general area of the neck. This is just a rough indication for a start.

start the head, establishing the volumes, size, and pose.

Working alone in the studio from photographs, you can set up a rough head to the correct dimensions and incorporate as much information as possible from the photographs. You should start by making an egg-shaped form on the armature with one axis approximately vertical and facing straight ahead. After the proportions are established and features placed correctly, you'll want to decide just how the head will be positioned, tilted, or turned. With this pipe armature it is possible to tilt the vertical axis of the head slightly and turn the head a little to one side to introduce movement into the design. You do this by spreading one hand out on each side of the head and firmly and slowly moving it in the direction you have chosen. If you want an upward or downward glance you must build this in from the start because the armature will not move in these directions.

PLACING AND DEVELOPING THE FEATURES

Careful placement of the features is very important in establishing a likeness. Using the point of your tool, mark the locations of each feature clearly. During modeling these lines will disappear. You will find it helpful to measure and mark the new surface several times as you go along. Go as far as you possibly can toward developing a likeness from the photographs. You'll find that you can gather a great deal of information from good photographs, but not everything you need to know. Most of all, the pictures will make you familiar with the subject's face and make you aware of what information is missing. As a result, during your subject's next visit to the studio you will use the time most efficiently.

At any time, it is helpful to look down on the head from above to observe how the forehead curves back to meet the sides of the head, how the cheekbones curve back toward the ears, and how the mouth curves around the horseshoe shape of the teeth. Look up at the head from a position below the chin to see the same curves from this angle. You may discover by this means that you have made one cheek farther back than the other, or that one eye bulges while the other is properly recessed. It is surprising how hard it is to see the third dimension. There is a tendency to develop one side of the face more than the other. In my case it is the right side. It is necessary to keep this possibility in mind and to correct for it periodically.

The preliminary modeling described here should be started just far enough ahead of the subject's second visit,

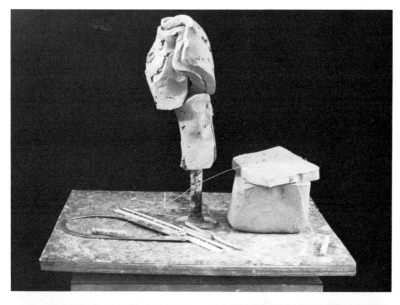

I put two more slabs of clay on the back to fill in the beginning of a cranium. The aim is to build the volume quickly at the beginning.

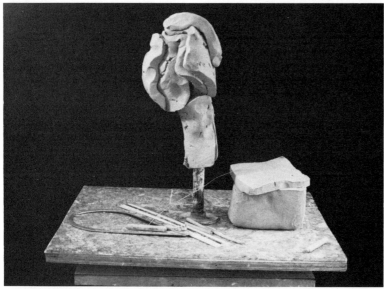

I put more thickness in front of the pipe to build the face farther forward and also add more to the cranium.

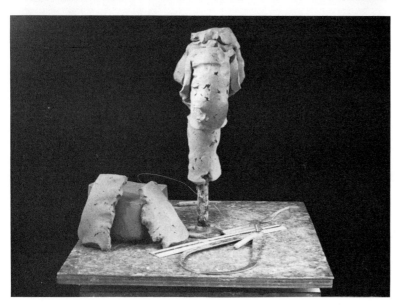

Here is a front view of the same stage as the previous photo. You can see that the width of the back of the head is beginning to develop.

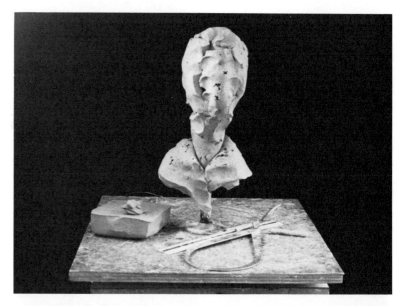

I add a half slice to each side of the face and blend it into the cranium. The foundation of each shoulder is made of a slice of clay folded into a triangle and pressed on to either side of the neck.

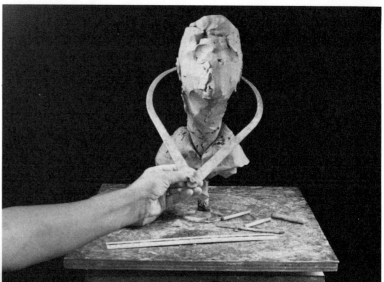

I set the calipers to the first measurement on the chart: ear to ear. The rough head was not quite wide enough. You can see where a little patch of clay was added on each side to build up the width.

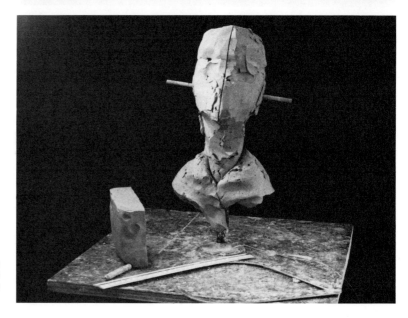

Next, I push a short wooden dowel into each side to mark the location of the ears, the points from which to measure other dimensions. I draw a line down the center of the face.

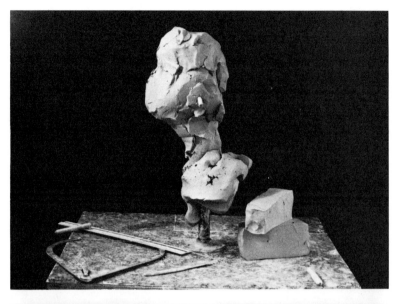

It is important to keep turning the stand to see how the piece is developing on every side. Here you can see the cranium is far too small.

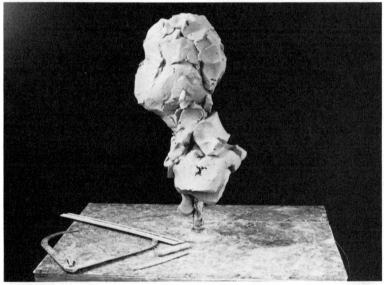

I build the cranium up to somewhat better proportion and fill in the back of the neck.

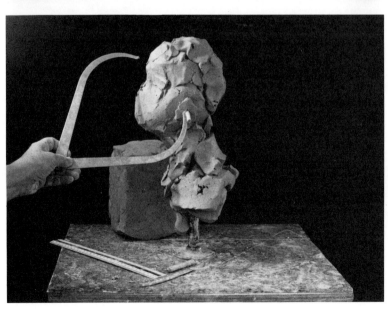

Next, I check the second measurement on the chart: the distance from the ear to the hairline. You can see that the forehead needs to be built forward.

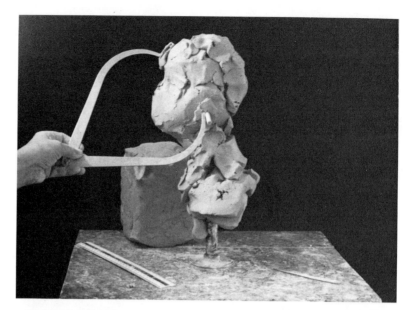

I add clay until the distance from the ear to the center of the hairline corresponds to the measurement on the chart.

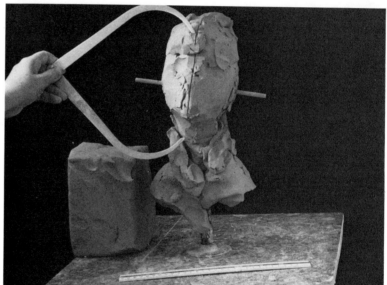

You can see the mark of the hairline crossing the center line of the face. I set the calipers to measure the length of the face. One point of the calipers rests on the hairline mark. The other point falls far below the face as it is developed thus far.

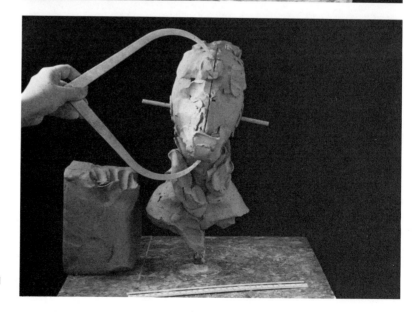

I add a chunk of clay to bring the chin down to the level indicated by the calipers.

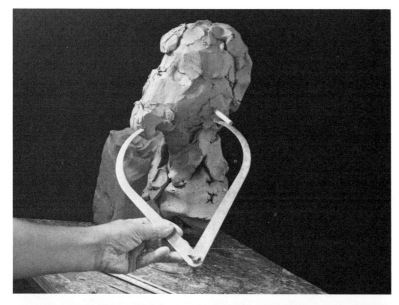

Next, I set the calipers to the correct distance from ear to chin and find that the chin is too far forward.

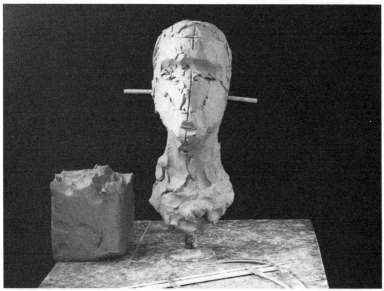

I cut the chin back closer to the ears and recheck the length of the face. Now these first four measurements are coordinated with each other.

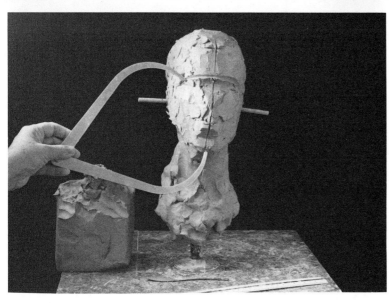

The next job is to determine the locations of the features. I set the calipers to the measurement from chin to eyebrows. In this picture one point is on the chin and the other point has drawn an arc across the brow line.

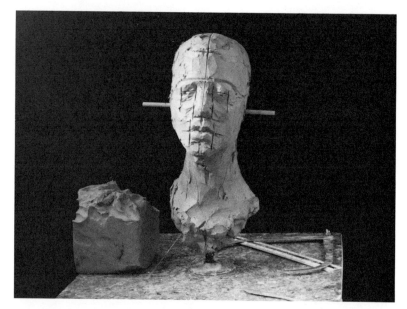

I measure the distances up from the chin to the mouth and nose and mark those levels. Then I mark the width of each feature. Here you can see I have started to shape the mouth and the nose.

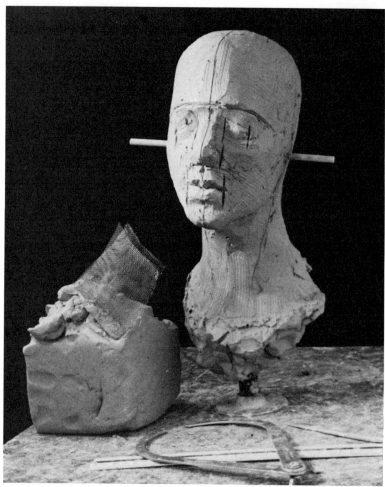

I use a piece of wire screen to scrape the surface of the head, clean off all the planes and clarify the forms. Then I redraw the marks for the placement of the features.

so that you complete it the day before your subject arrives. In this way, the clay will still be in optimum condition. Your ability to gauge the time required for the preliminary modeling will improve with practice. I usually need about three days.

WORKING FROM LIFE

With the basic shapes established and the features properly placed, it is time to work on the likeness. In front of the live model, you will notice many curves and planes that do not show in the photographs. Each feature begins to gain individuality as these observations are incorporated in the head.

During this session, I prefer to have the subject active in the studio rather than sitting still. This gives me an opportunity to observe characteristic attitudes and expressions.

From time to time I ask the sitter to look at me for a few moments while I compare the real face to the clay one. Then I begin making the changes that seem necessary. While I am carrying out this activity, the subject is free to roam around the studio or stand behind me and watch. When that is done I ask to see one side or another, or a particular feature I want to work on next. Again, I study the real head for a moment and then go back to modeling. We carry on a conversation while this is going on and every time I look at the subject I can see something about the real head that is not portrayed in the clay one. Since every side and angle must be studied, every feature from top, bottom, or either side is important. It doesn't matter which way the subject is turned because there are always plenty of important details for me to observe. Occasionally, I ask to see a particular view, but most of the time I just make use of whichever aspect of the subject is presented.

Gradually, these modifications add up to the beginning of a likeness. Then I narrow my focus to those parts of the portrait that look least like the subject.

Some artists like to concentrate on one side of the face during the period of working from life and then between sessions model the other side roughly like the first, correcting for asymmetry at the next session. You might want to try this and eventually work out a pattern that will suit you personally. Your pattern is likely to change as you gain experience.

During this session some of my adult visitors like to look at my art books or chat with a friend who has come along, but generally they are more interested in watching the development of the portrait. One young man stood behind

me the whole time. He didn't want to miss anything. I had to look over my shoulder to observe him. Eagerly he offered suggestions that I carried out. At one point I didn't quite understand a comment he had made. I offered him the tool, saying, "Show me what you mean." He backed away horrified, and said, "Oh, I wouldn't dare touch it!" When the portrait was finished, he commented, "I never thought I had any artistic ability, but you have done some of the things I suggested and it looks wonderful."

A child often plays with clay for an hour or more with only a few interruptions when I ask to see a particular aspect of the child's head. After a short break a child will generally return to the perch at which time I sometimes substitute paper and crayons for clay.

We work until everyone starts to get tired, usually two or three hours. The time goes very quickly. Since the subject does not have to sit still it is not as fatiguing as sitting for a painted portrait. By the end of this session the portrait has begun to bear a distinct resemblance to the subject, but it is not completely satisfactory. Work has concentrated on the face, leaving the hair and neck for later.

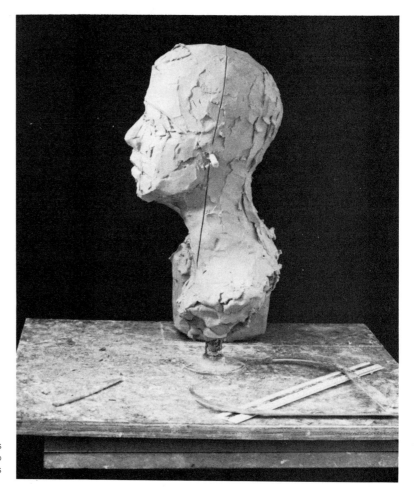

I draw a vertical line to indicate the tilt of the head. This approximates the middle from front to back. The ears go behind the midline; the pit of the neck is at the base of this line.

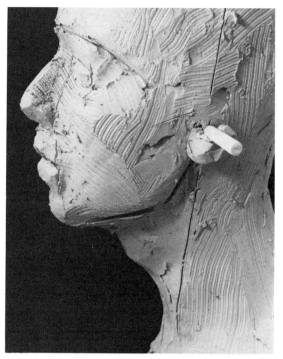

I add an earlobe now so it is easier to mark the jawline. Next, I fill in the throat.

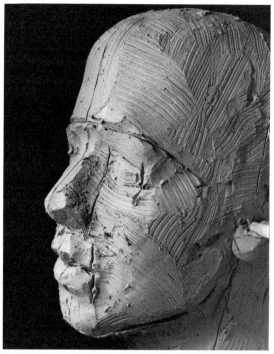

Here you can see the bulge caused by the cheekbone, the rough beginnings of the planes of the nose, the curve from the nose to the brow, and the swelling of flesh above the eye that covers the upper part of the eye socket.

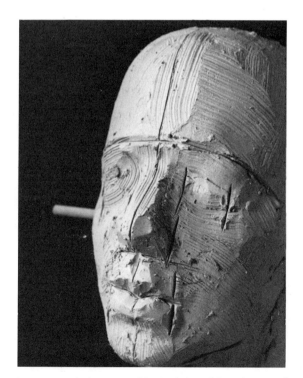

Here you see the beginning of the two halves of the red margin of the lower lip, the central butterfly and two wings of the red margin of the upper lip, and the vertical indentation from the bottom of the nose to the margin of the upper lip. Again, note that the upper lip is the entire area from the nose to the mouth, and the lower lip is the entire area from the chin to the mouth. The part where lipstick is applied is only the margin of either lip, not the whole lip.

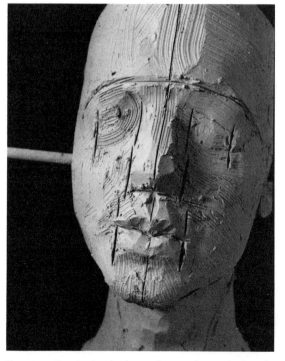

Here you will notice that the distance between the eyes is about the width of an eye. The widest part of the nose is just a little wider and the mouth is still a little wider. There is a slight cleft in the chin.

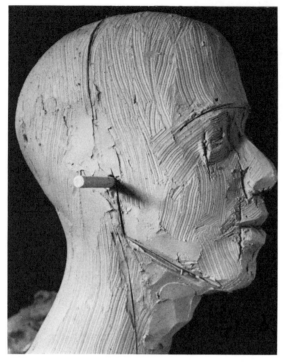

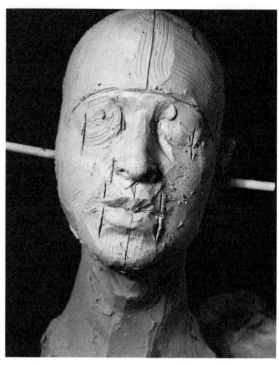

Notice that the eyes are well to the rear of the root of the nose; the bottom of the nose lies half inside the front of the face and half protruding from it; the mouth curves back even farther than the nose; the jawline forms an angle of four o'clock on this side and eight o'clock on the other side of the face.

Next, I model the nose more carefully. You can see that the round end dips lower than the nostrils on either side. I smooth out the ramps from the bridge of the nose to the cheeks on each side, and I model the triangle from the root of the nose to the brow line.

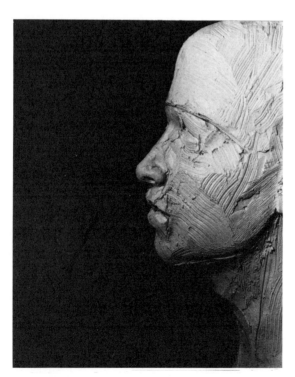

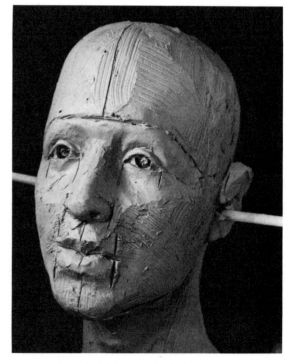

On the bridge of the nose where the underlying bone ends, there is a very slight bump. I match the shape of the tip of the nose very carefully to the photograph.

I estimate the level of the eyes under the brow, model the eyelids, and cut in the eyeball. Next, I model the slope of the lower lid down to the cheekbone.

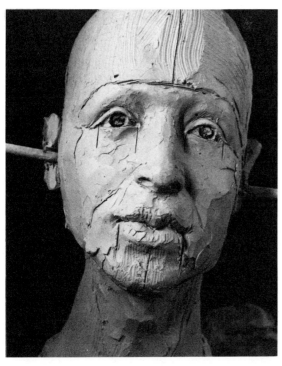

Going back to the mouth, I fill out the shape of the red margins of the lips. The upper one has a rather definite edge, but the lower one blends softly down toward the jaw. Only the center of the edge of the lower lip has a well defined border.

I add the ear after all the other features have been started, chiefly because it stands away from the main body of clay and tends to dry out faster than the rest of the head.

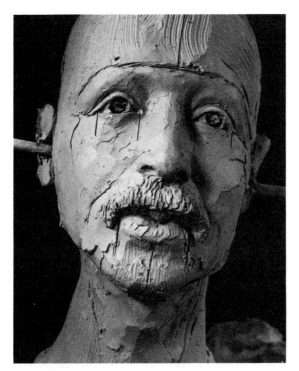

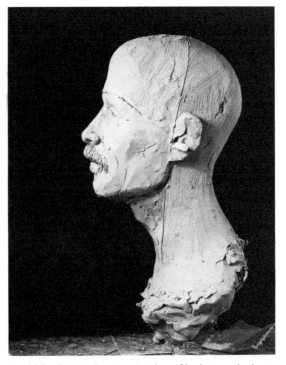

Next, I develop the contours of the cheeks and the furrows running down from the sides of the nose beyond the ends of the mouth. Within this frame I place the moustache. Notice how the edges of the moustache relate to the bottom of the nose, the upper lip, and the corners of the mouth.

I model the chin, matching it against the profile photographs, locate the hollow of the cheek, and fill out the muscle just below it.

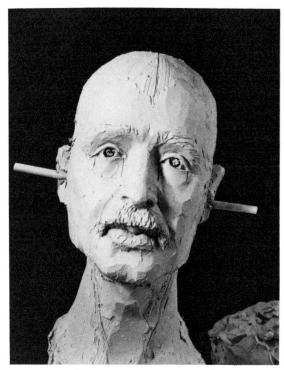

Next, I model the eyebrows roughly and begin modeling the forehead.

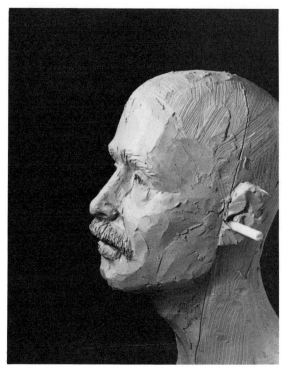

The brow ridge shows pretty well in this photograph. It is more prominent in men than in women and it is uniquely shaped in each individual.

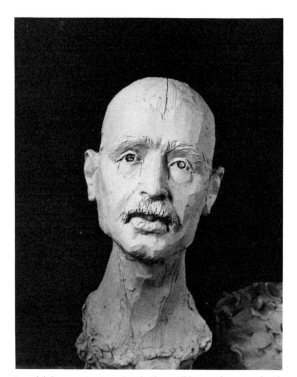

I model the ears in more detail. They will be partly covered with hair, but modeling the whole ear helps to ensure that the volume of hair over them is adequate.

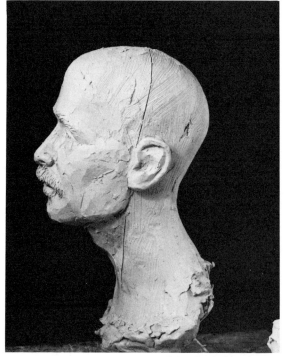

A side view shows that the ears are not fully refined. That is because they will only serve to hold the hair out in a lifelike shape.

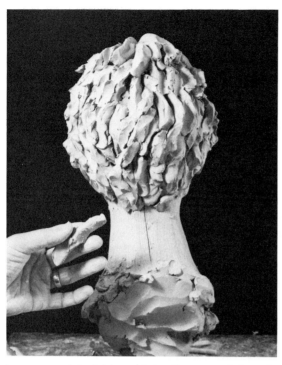

I press worms of clay lightly onto the head in a pattern similar to the way in which Richard wears his hair.

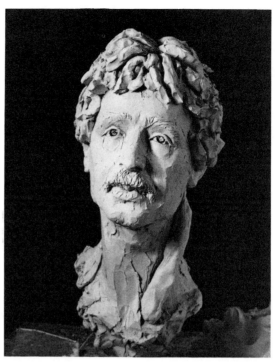

These rough pieces of clay are only intended to approximate the volume of Richard's hair and its general pattern. Next, I put a fat roll of clay in the position of the long muscle that goes from just behind the ear down to the front pit of the neck.

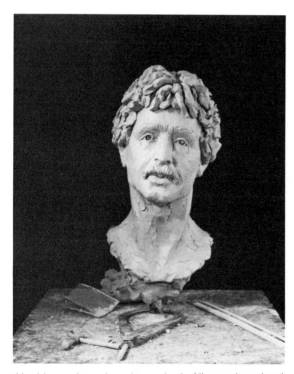

I blend this muscle into the neck on each side, filling out the neck and adding material around the shoulders and collarbone.

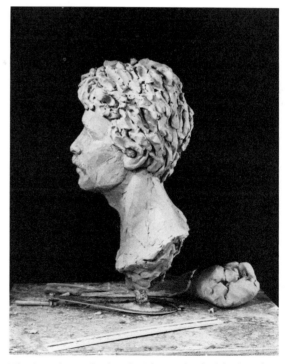

When I turn the stand to the side, I discover that the Adam's apple is a little too low and the angle below it cuts in too sharply toward the neck. I must correct errors like this as soon as I notice them.

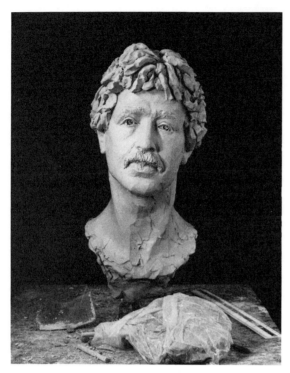

I round out the cheek muscles, jawline, and the muscles of the brow.

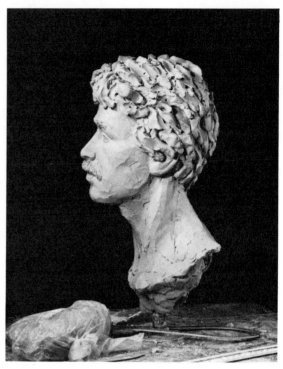

I keep turning the stand and refining all the facial contours as I go.

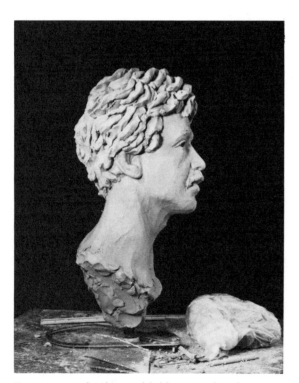

Here you can see that I have modeled the ears, neck, and eyes more carefully. It is not a good idea to model one feature completely before working on another; they rarely fit together gracefully if you work that way.

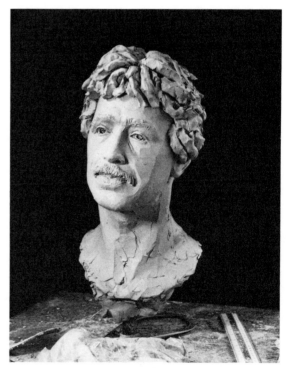

Richard's left side seemed to be modeled too far forward. You can see where I have cut away the cheek.

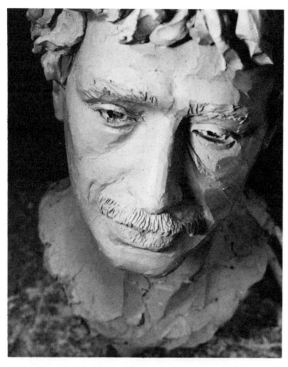

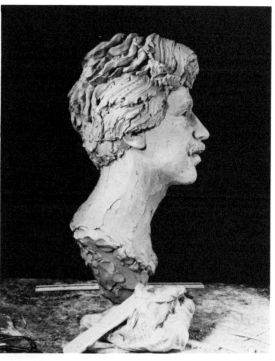

A view from above indicates that not only was the cheek modeled too far forward but also the eye seems to bulge. The eye will also have to be cut back and remodeled.

Here I have begun to fill in the hair and "comb" it with the ragged end of a broken paint paddle. I add texture to the hair by following the pattern of Richard's haircut.

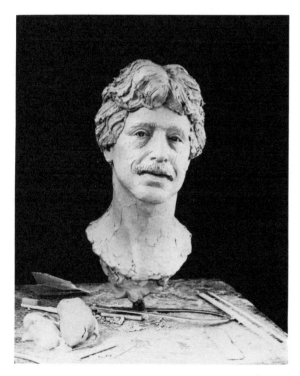

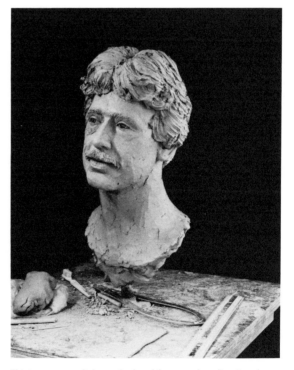

I fill out the hair and "comb" it so that it provides an interesting contrast. The face is not smoothly finished, so the contrast is not too great. The brow and moustache have texture similar to that of the hair.

Shining a strong light on the head from another direction draws attention to the very rough modeling under Richard's right eye, and a heavy mark on the neck under the ear. The hair at the temple needs to be blended into the face. Also, there are some sharp edges between the chin and cheek which must be modified.

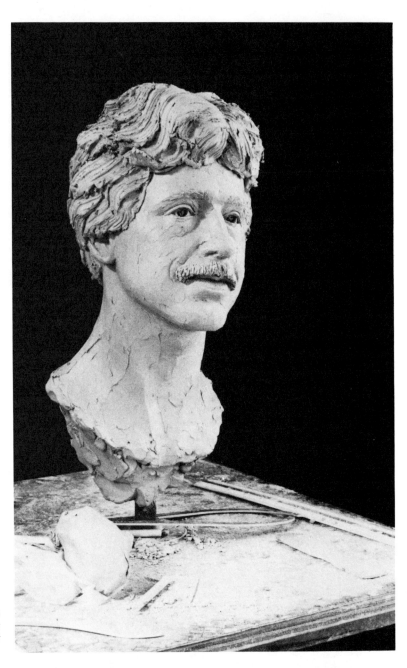

I move the light to the other side and sharpen the line between the lips. Making this line quite deep at the center and at both sides of the mouth creates a dark shadow that balances the darkness of the eyes.

CHECKING THE CURVES AND PLANES

After the first modeling session, you need to study all the curves and planes of the head in various lights. As you move a light over the work from different directions, you will notice awkward curves or undercuts that make too dark a shadow. Perhaps the expression of the face will change in a different light. A frown may appear because the curve of the forehead is not smooth enough. So change the lighting in several different ways and study every aspect of the sculpture each time. These problems should be corrected before the next modeling session with the subject.

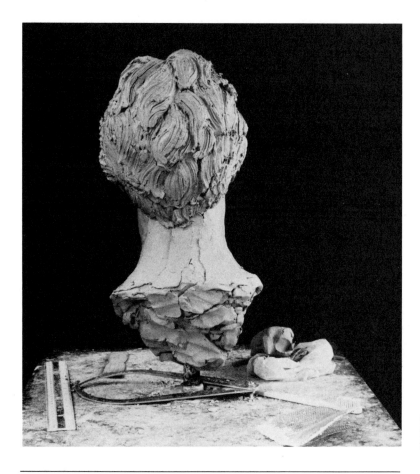

During the last modeling session, I check the volume of the hair compared to the neck, the contours of the hair over the ears, and the tilt of the head and shoulders.

FINISHING THE MODELING

The arrangement of the hair and the neckline can be designed between the two modeling sessions so that the person commissioning the portrait can see your general design plan at the same time you are finishing the likeness.

With all of this out of the way, the sitter's third visit and second session for modeling from life can be devoted to refining the likeness. This may take anywhere from half an hour to three hours. The work is much slower and more painstaking as you come closer to the exact effect you want to achieve. It also becomes easier at this stage to pinpoint the places where the work fails to convey a likeness.

One good way of getting a fresh view of the work is to look at the sculpture in a mirror. After working steadily on a piece of sculpture for several hours, it can become difficult to "see" it clearly. Any trick that heightens your powers of observation makes it possible to advance the work further along before the clay becomes too dry. Looking at the work from the greatest possible distance makes a startling difference in how it appears to you. In spite of all these strategies, the time does come when the only productive move is to get away from the work completely and do something else for a while.

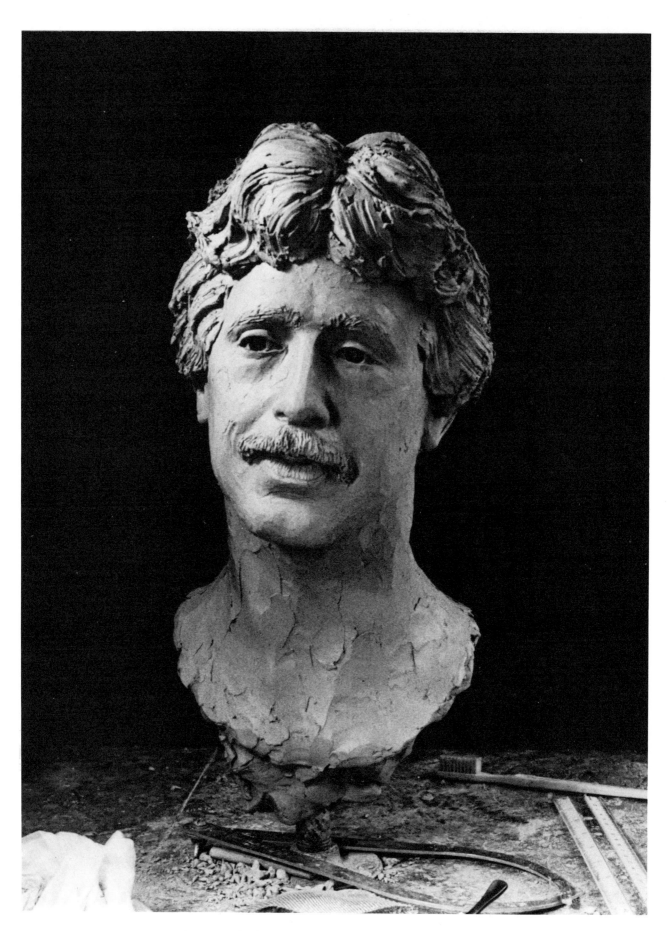

If the subject is a very restless person, you should arrange for shorter, and more frequent sessions. These should be scheduled as close together as possible, because the clay continues to dry slowly even when covered with plastic.

During the last session the work is carried to the point where the client declares it finished and gives permission to fire the clay.

With most works of art it is the artist who decides whether the objective has been achieved. With a portrait, however, you should expect to please the subject as well as to live up to your own standards.

Friends often ask how long it takes to do a portrait. The time varies with each job. Certainly it takes many more hours than those spent with the subject in the studio. I keep a log in an effort to allocate costs for each job, to see how my time is apportioned between creative, bookkeeping, advertising, and production tasks, such as firing the kiln. It also satisfies my curiosity as to whether the modeling goes more quickly as the years go by. It does.

FINAL REVIEW

Before you do fire, it's worth the time and effort to do one final check. Otherwise after the sculpture is fired, finished, and mounted in place you may notice an irritating imperfection that can no longer be corrected.

There are various ways of checking for flaws. One is to light a candle and then turn off all the other lights. Slowly turn the modeling stand while observing each curve and plane as revealed by this small light source. It is possible to see interruptions in the flow of curves, weakness in the modeling of planes, and awkward shadow shapes more clearly with a pinpoint light source than with general illumination. Then take your floodlight or other strong light source and shine it on the portrait from many different directions. When you have satisfied yourself that everything is in order, it is time to allow the piece to begin drying in preparation for hollowing it out.

(opposite) I refine the likeness in every feature and check their relationship to each other. I study Richard's expression from every angle and feel satisfied that the modeling is complete.

CHAPTER 3

MODELING INDIVIDUAL FEATURES

In this chapter I will demonstrate step-by-step how to model individual features—the eyes, nose, mouth, chin, ears, hair, and neck and shoulders. In each demonstration I am aiming only for the basic shapes. Obviously, when you do a portrait you will observe and attempt to reproduce individual variations, but here is a discussion of what forms to look for while building each feature.

THE EYE AND EYEBROW

Keep in mind while modeling an eye that it is a globe set inside a bony rectangle, which is tipped down toward the outer edge of the face. This will help you see the shapes you are looking for and reproduce them convincingly. With the tips of your fingers feel the edge of that bony opening in your own face and the bulge of that globe under your closed eyelids. Watch someone else's eyes as they roll from side to side and see how the eyeball pushes the eyelid out in the direction of the person's glance. When you model a pair of eyes, hold a straightedge in front of the face to be sure that the corners of the eyes all line up, if they do so in your subject's face. If the corners of the eyes are not level, the straightedge will help you observe which one is higher and which one is lower, as it sometimes happens.

On most faces there is a distance between the inner corners of the eyes about equal to the width of one eye. For some individuals the distance is a little less or a little more. This information will be on your measurement chart and is important to note for achieving a likeness.

Look for the steep slope of the upper lid on the inner side of the eye and the wider curve down on the outer side. Notice the double curve of the edge of the lower lid and the way it rises toward the outer corner of the eye. The rim of the lower lid should be slick to catch the light and attract

attention to the eye. Make it slick by smoothing it with a modeling tool. Observe how the circle of the iris usually rests on the lower lid and is partly hidden by the upper lid. The creases under the eyes, their length, distance from the edge of the lid, and the way they follow the curve of the lower lid or sweep away across the cheek are different in each person. You will notice that the eyebrow follows the upper edge of the bony eye socket for most of its length and then sweeps away above the socket as it rounds the side of the face. Check this by feeling your own eyebrow.

The pattern of hairs in the eyebrow is important, too, some growing up from below and others down from above to meet in a ridge which runs outward toward the side of the face. Notice the depth of that ridge in a three-quarter view of someone else's face.

THE EYE AND EYEBROW

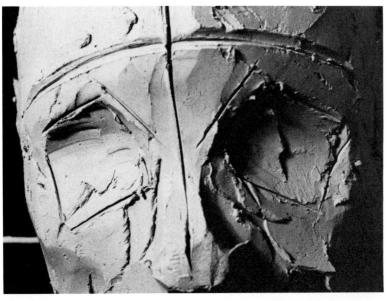

1. First I form the eye socket. The bony brow and the cheekbones combined make a tilted rectangle that tips down at the outer corners. This is the frame of the eye socket.

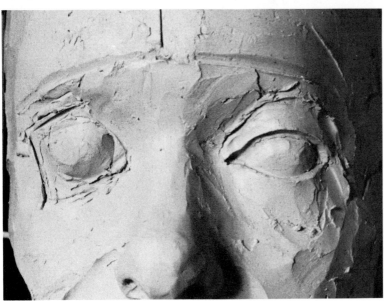

2. I form a hemisphere of clay for the eyeball and set it into the bony frame. Then I add strips of clay to form the upper and lower lids, building the curves of the lids to show the direction of the gaze.

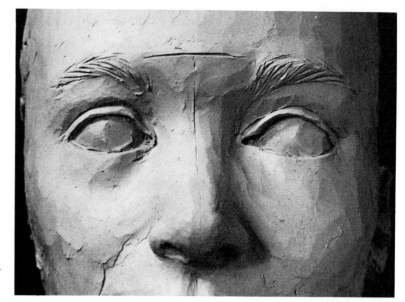

3. I model the soft curves over the bony eye socket between the eyelids and eyebrows, and refine the upper and lower eyelids and the shape of the eyeball. Checking the alignment of the eyes, I add the eyebrows, which do not lie perfectly flat on the skin but rather stand out in a slight ridge.

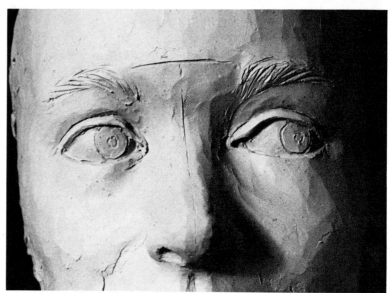

4. Here is one way of indicating the iris and pupil of the eye that gives the effect of very pale eyes.

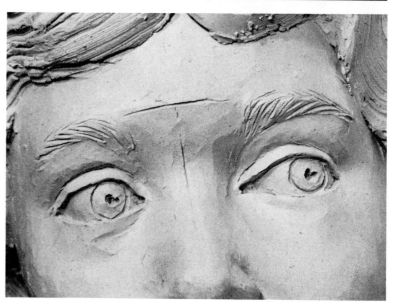

5. This is another style of eyeball that has often been used by sculptors. It seems to represent a piercing look and perhaps an intermediate color.

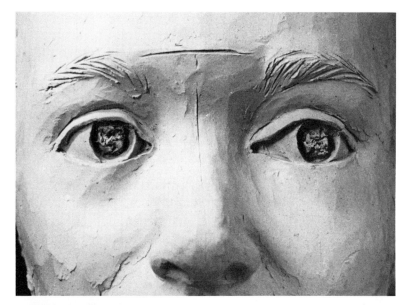

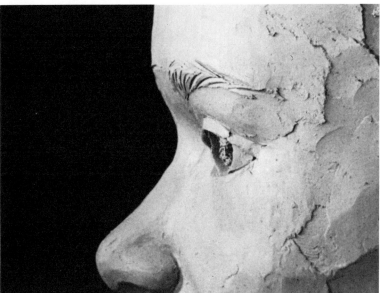

6. I usually make the iris and pupil by digging out a little clay, and then stirring around the clay left in the cavity to produce complex shadows. I vary the depth to alter the impression of tonal value. The deeper the hole, the darker the value.

7. I check the eye from the side to see that it is far enough behind the root of the nose and to be sure that it has not been modeled flat.

THE NOSE

The nose, the most prominent feature of the face, is the cutting edge of the wedge shape of the facial structure. Look down on someone's head from above and you will see that it leads all of the other features forward. Notice, however, from the side that the entire body of the nose is not simply set upon the front of a flat face. Half of the depth of the nose is set into the face above the dental arch.

If you consider the elements that comprise the nose separately, you will learn what to look for in distinguishing one nose from another and in developing a likeness. When looking at the face from the front, the triangle formed by the top of the nose and the space between the eyebrows has a characteristic shape in each individual. The bridge of the

nose, the hard part, establishes the dominant characteristic of the nose, varying from the most obtrusive hawk nose to the least developed button nose of an infant. The angle of descent from the brow and the length of the nose are unique to each person. Note too that the relationship between the length of the nose and the length of the brow varies significantly from person to person.

The wings, small and low in a baby, also vary enormously with age, sex, and race. The back of the wing has no cartilage beneath and is softly rounded. Although it is soft, you'll discover this part has individuality too.

The septum usually descends lower toward the mouth than the wings on either side, but I have seen the reverse in a few cases. The edge of the cartilage on either side of the tip of the nose, forming the forward edge of the nostrils, gives a sharp definition to those planes. Where the cartilage of the two sides of the nose tip meet there is often a visible line or depression, sometimes seen only in good light. On some noses, the line is hidden by fatty tissue.

In an infant the head is nearly all cranium, the facial features occupying a small area with the nose descending into the bottom third of the head. As the child grows, the face grows more rapidly than the cranium and by adulthood, the nose descends from the midline.

THE NOSE

1. I build the bridge of the nose first and establish its length. Then I work on the shape of the transition to the brow line, that triangle at the top of the nose.

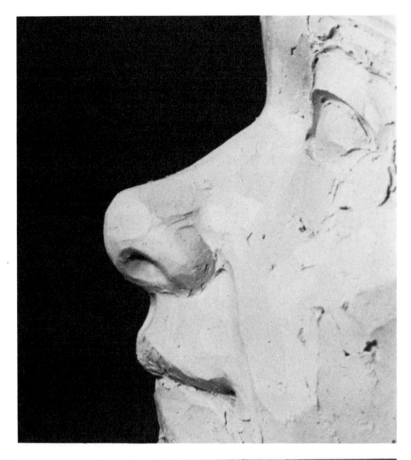

2. Turning to the side, I check the profile, the incurvature below the brow, the break in the line where the bone ends and the cartilage begins, the shape of the septum, and the distance from the top of the upper lip forward to the tip of the nose.

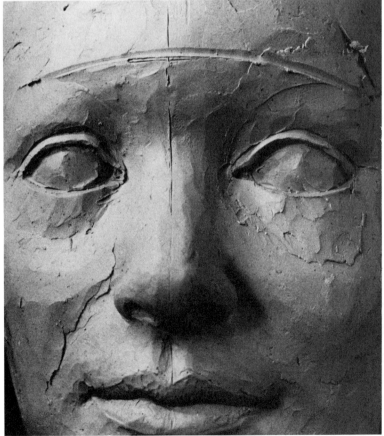

3. Returning to the front view, I build the wings of the nose to the width shown on the measurement chart and indicate the planes of the tops of the wings. I check the shape of the septum from the front and its level relative to that of wings.

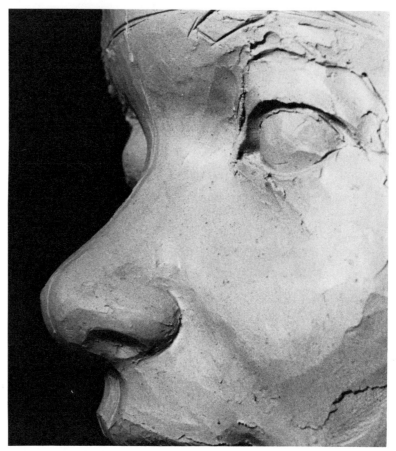

4. Again turning to the side, I refine the size and shape of the wings, build the transition from the bridge of the nose to the cheeks, and define the furrow around the edge of the wings. The shape of the nostrils becomes clearer. I check the distance from the front of the upper lip to the back of the wings of the nose.

In spite of these variations there remains the universal structure: the brow ridge, the bridge, the nostrils, septum, wings, the furrows above the wings, and the lateral surfaces that span the distance between the bridge of the nose and the cheeks. Compared to the mouth, the nose is fairly immobile and, thus, easier to observe and model.

THE MOUTH

When modeling the mouth, you are most concerned with the shape of the lips. But remember, the lips are not just the part where lipstick is applied. This is really only the red margin of the lips. The shape of the upper lip begins where the nose ends, and the shape of the lower lip ends where the chin begins. Just below the septum is a furrow with a ridge on either side dividing the upper lip in half vertically. This furrow is deeper on some faces than on others and varies in width as well. The curved surface on either side of it slopes outward and back around the dental arch to a furrow at the edge of the cheek. The red margin of the upper lip is formed by three segments, a middle one that bulges down toward the center of the lower lip, and two wings that taper down toward the deep corners of the mouth. The mouth is formed by the red margins of the upper and lower lips.

The red margin of the lower lip is made of two sections that fit into the curves of the upper lip. Study these sections and how they fit together in your subject's face. Look at the side of the face and see how far back the corners of the mouth extend compared to the side of the nose and the eyes. Notice also from this point of view, the angles between the bottom of the nose and the upper lip, between the upper and lower lips, and between lower lip and chin.

The fullness of the red margin of the lips varies not only from one individual to another, but also in the same individual depending upon the expression of the mouth. A pout makes the red area fuller, a wide smile stretches it thin. The indentations at the corners of the mouth are very complex. All of this is complicated by the great mobility of the lips, which makes them the most expressive feature of the face.

You'll find that it is easiest to portray the mouth in repose or with a very slight smile—just enough to create a pleasant expression. Portraying a smile is difficult because it is apt to look more like a smirk. The wider the smile, the more the rest of the face is altered and the more difficult it becomes to attain a spontaneous and convincing expression in the portrait.

THE MOUTH

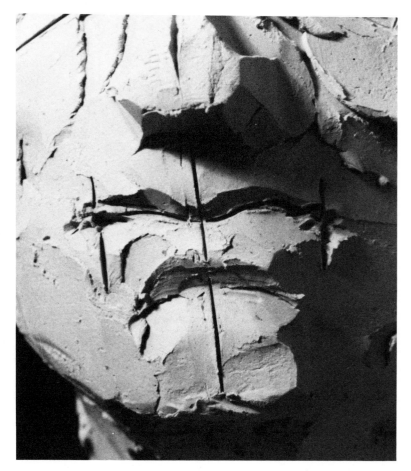

1. I start the mouth by making a curved slit at the measured distance above the chin. Then I mark the locations of the corners of the mouth.

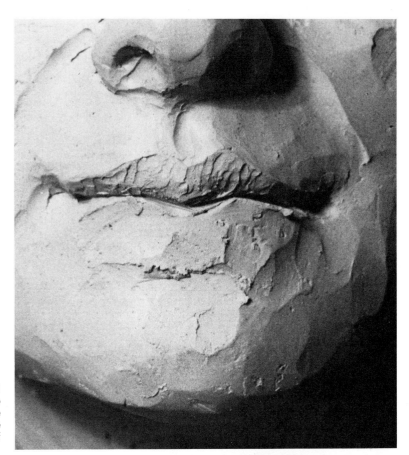

2. Next I build the upper lip starting with the central furrow below the septum, building out and around to the lines that run from the sides of the nose to the corners of the mouth. These lines are called the nasolabial furrows. Finally I shape the three sections of the red margin of the upper lip.

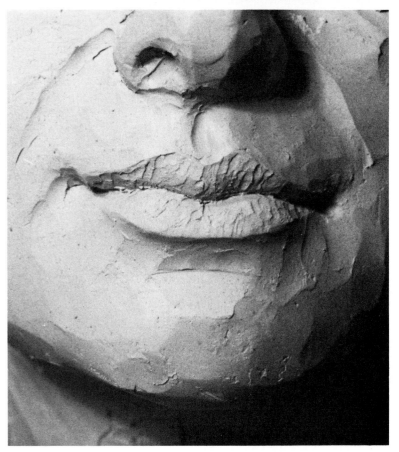

3. Then I develop the lower lip starting at the horizontal furrow at the upper edge of the chin, curving around each side to the corners of the mouth and, finally, building the two lobes of the red margin to fit the curves of upper lip.

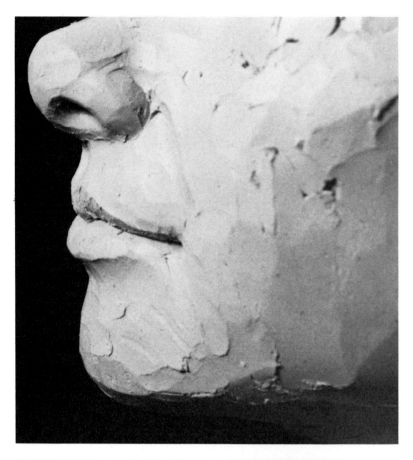

4. Turning the sculpture to the side, I check the alignment of the lips. Should the lower one protrude more than the upper, or should it be just the reverse? Are the angles between the upper lip and the nose and between the lower lip and the chin accurate? Does the side of the mouth curve back far enough? Should the corners droop? If so, how much?

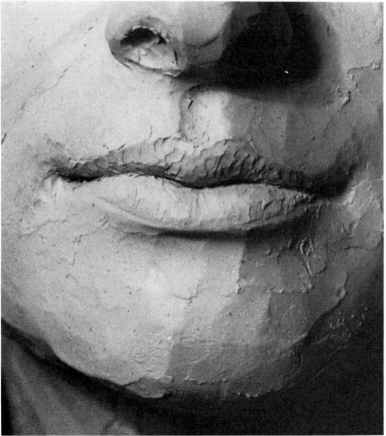

5. Returning to the front view, I refine all the curves, blending the soft ones into each other, defining the more abrupt changes in plane. I mark the groove around the edge of the red margin of the lower lip and give a slight texture to the red part of both lips.

THE CHIN

The chin is formed by the forward portion of the jawbone, which has small lumps on each side of the midline. You can feel with your fingertips the more or less square front of the jawbone. In some, especially men, the effect is quite square and in others the curve is fairly smooth around the front of the lower jaw. There is sometimes a dimple in the chin where the tissue attaches to the bone. This also varies in both depth and shape from person to person and it seldom if ever appears on a baby's face.

The furrow across the top of the chin just below the lower lip is sometimes a sharp crease and sometimes just a gradual change of plane. It loses its crispness with age and sometimes breaks into several small lines. Observe the frontal curve of this crease if there is a definite line, and from the side notice the angle between the lower lip and the chin at that line.

The chin is not nearly as mobile as the mouth. We need not consider the changes of shape with extreme facial expressions because extreme expressions are not suitable for portraits. Of course, if you wrinkle up your face and pout, your chin will move up, and if you wear an exaggerated grin, the chin will stretch out sideways. But the minor changes of the expression of a portrait do not affect the chin as much as they do the mouth.

With overweight subjects there may be a double chin that hangs from a line just behind the first chin and varies enormously in size and shape according to the amount of fatty tissue. The drape of the double chin changes with the pose and the turn of the head. It can be seen from the front as well as the sides and its accurate representation is as

THE CHIN

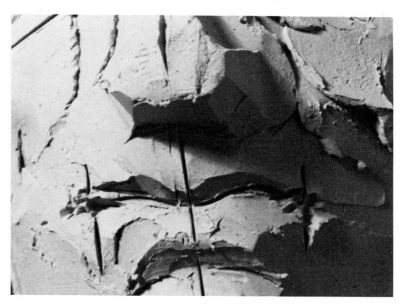

1. To start the chin I mark the length of the face, cut it square at the bottom edge, and then model the crease between the chin and the lower lip.

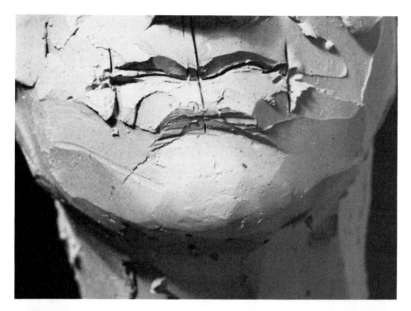

2. Then I round the chin from this crease to the bottom and from side to side, blending it into the rest of the jaw.

3. I turn the sculpture to the side and check the angle between the lower lip and the chin. Then I check the shape of the complete curve all the way from the crease at the top around the front and back under to where it reaches the neck.

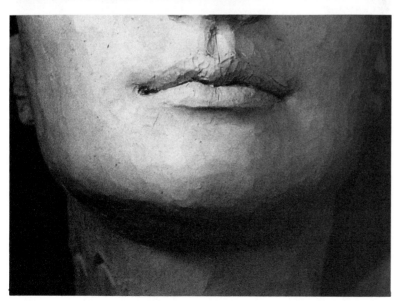

4. Working again from the front, I develop the transition from the chin to the lower cheeks and the outer edges of the lower lip. I turn the subject's face in the light to look for any indication of a cleft in the chin, however subtle, and if there is one, represent it in the clay.

important as that of any other curves or planes of the head.

One of the loveliest curves of a baby's face is surely its smooth little chin, while the large square chin on many men enhances their masculinity. When modeling any one feature, remember that it is part of the total portrait and therefore must be modeled in a manner consistent with the rest of the face.

THE EARS

I have heard it said that if you want to study the appearance of a criminal for later identification, concentrate on the ears precisely because they are unique. In spite of their seeming complexity, all ears are designed to gather sound and funnel it into a small canal.

Looking at the ear from the side of the head, you see the outer shell shaped a lot like the letter C and an inner rim inside it that has two branches at the top that end under the upper edge of the outer rim. The outer rim curls down the front and into the center of the ear toward the canal. The two rims are parallel as they descend at the back of the ear and turn toward the ear lobe. The soft curve of the ear lobe ends at the back of the jaw. Above the front of the lobe is a little curved flap that rises along the front of the ear to join the outer rim.

THE EARS

1. I start the ear by pressing a half circle of clay firmly against the head, just behind the stick that marks the ear hole. This half circle of clay acts as a spacer between the skull and the outer shell of the ear, so that the outer shell of the ear will not be flat against the skull.

2. Then I add a large c shape for the outer ear, mark a groove to separate the inner and outer rim, model the two branches at the top of the inner rim, the upper branch rather fat and round and the lower one narrower and sharper.

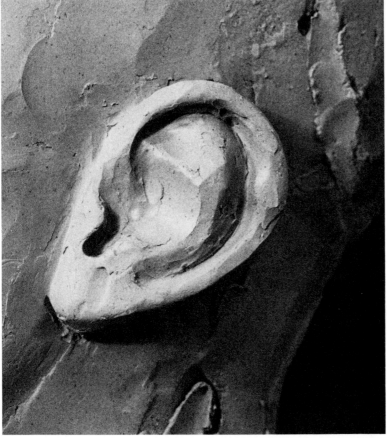

3. Next, I make the earlobe and all the little lumps above it leading back to the front of the outer rim. Then I model the outer rim more carefully.

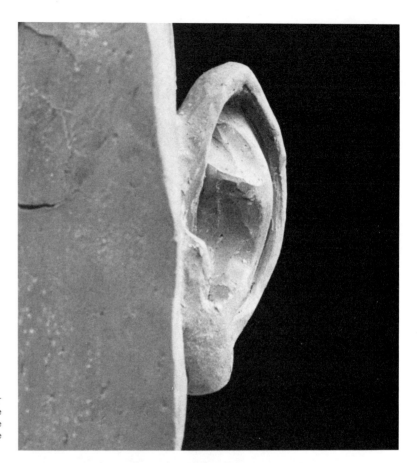

4. I turn the sculpture to face front, press the top of the ear closer to the scalp or pull it away depending on the subject, then pull out or press in the midsection of the outer rim as well as the earlobe, and carefully shape the junction of the earlobe and the jaw.

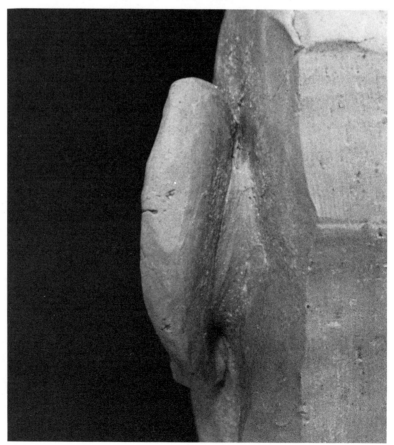

5. Turning the head to the back, I blend the planes of the back of the ear and the earlobe into the back of the head.

When positioning the ear on the head, note that it is located just behind the midline of the side of the head, and that the slant of the front edge of the ear is nearly parallel to the slant of the bridge of the nose.

To model an ear I start by drawing a midline down the side of the head from top to bottom, dividing the front half from the back half. Then I draw a line from front to back at the level of the eyebrows and another at the level of the bottom of the nose. The ear goes between these two parallel horizontal lines and behind the vertical line slanted a little bit to match the slant of the bridge of the nose.

If you stand behind someone and look at the back of the ear, you will see that it stands away from the head like a very short magaphone with a flared rim. Put your finger behind your own ear and feel the shape of the funnel between the outer shell and your skull. Run your finger up and down and feel how it stops at the bottom when it hits the earlobe. I form a piece of clay like a hockey puck, with one flat side, and stick this onto the head to form the part you just felt with your finger. Then I add a roll of clay to make the flared shell of the ear and follow the procedure you see in the photographs.

The more ears you model, the more familiar you will become with this feature. With practice and experience modeling many portraits, you will begin to notice the individual differences in ears.

THE HAIR

The first principle to follow when modeling hair is to treat the hair as major and minor volumes rather than as a collection of threads. You must stand back and consider the relative sizes of the hair mass and the face, and look for the widest and highest reach of the hair. Then you can move in close and establish these forms by starting with the big, general shape. After that is accomplished, design the minor subdivisions.

The second principle to follow when modeling hair is to avoid considering any aspects of surface texture until after all these forms are established. The color of the hair affects how you handle the surface. To indicate a lighter color hair, you develop a relatively smooth surface. To indicate a darker color, you'll want to create more active shadow patterns. The actual texture of the hair will determine the way in which you create these shadow patterns. For the lank black hair of an Oriental, you might use straight strokes of a coarse brush, such as a whisk broom making many deeply incised lines. Then you might smooth off a few small areas to simulate the bright highlights of glossy black

hair. Woolly hair can be textured with roughly crumpled terry cloth, simply by covering the surface with small bits of clay, or by making a pattern of dents with the tip of your modeling tool. For fine light hair shape the volumes carefully and smoothly and then give it slight texture with a very soft brush.

The third important principle to bear in mind when modeling hair is that the hairline is not really a line. There is a gradual transition from bare skin to heavy hair growth. Unless you observe and portray the transitional areas, it will seem that you have put a wig on your portrait. This transition is made by *losing* the edge of the textured hair in a few places where it meets the skin. If this cannot be done at an exposed hairline, then design a wave of hair so that it falls close against the face, and at some point let the texture of the hair disappear for a short space against the skin of the cheek or forehead.

The hair in this demonstration is wavy, but the principles and techniques can be adapted for lank, curly, and woolly hair.

THE HAIR

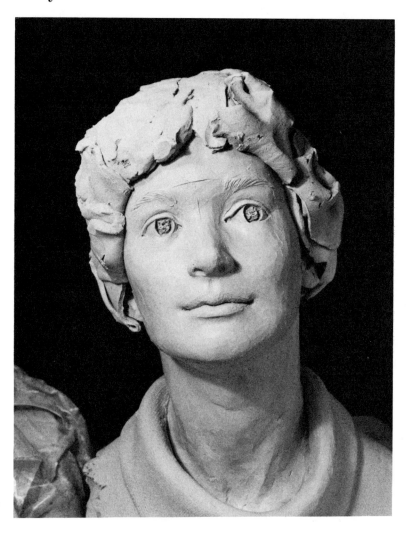

1. I fasten slabs of clay on the head until I have the approximate volume and shape of the hair established.

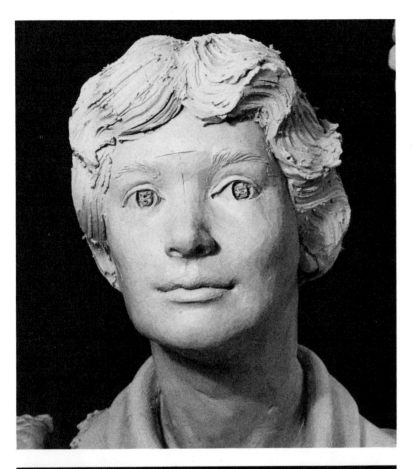

2. I go over the hair with various tools to add texture and create shadows that give a wider range of tonal values. At the same time, I use these tools to continue influencing the shape.

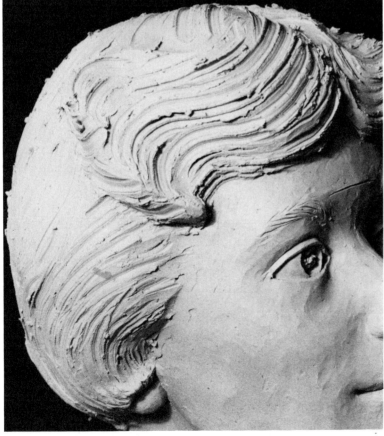

3. Next, I study the transitional area and blend the hair into the face where this is appropriate. I check the whole area of hair, moving the light source to detect any awkward shadows or ungraceful lines.

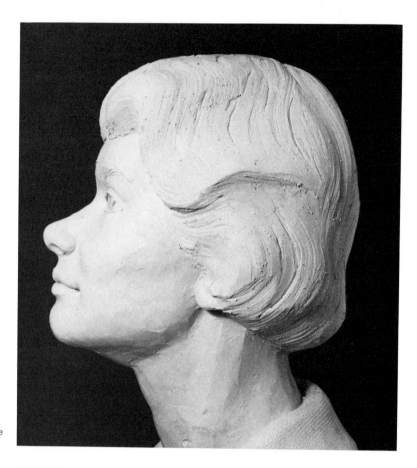

4. I improve the design of the flow of waves to direct the viewer's eye around the sculpture.

THE NECK AND SHOULDERS

I seldom model a portrait beyond the neck and shoulders, but I generally include these features very roughly, even if I intend to eliminate them later on. Doing so helps clarify the pose of the head in relationship to the body, and is therefore worth modeling anyway. The neck and the shoulders also provide a proper base upon which to model the edge of clothing or jewelry. It enables me to include details of the sitter's dress, and thereby, to help complete the overall portrait.

The neck is really just a column that tips forward at the top where it meets the head. You'll notice that the top of this column has a larger diameter than the bottom. Also, it slants back toward its lower end where it joins the shoulders. Look at the side of someone's neck and you will see a muscle (the sternomastoid muscle) making a diagonal line from up behind the ear down to the pit of the neck. This diagonal line divides the neck into two triangles: the forward one above, whose front edge shows the Adam's apple, and the larger triangle at the back, one of the sides of which is formed by the top of the spinal column.

The neck rises out of the middle of a base composed of the collar bone in the front and the shoulder blades behind.

The shoulder blades are covered by muscles (the trapezius muscles) that start at the base of the skull behind and slope out to meet the ends of the collar bones. Beyond this union on either side are the tops of the arms that seem to "swing from the ends of a trapeze." Slanting forward below the collar bone are the pectoral muscles.

Before starting a portrait, I often find there is a period of inertia and also of awe at the big job ahead. I overcome this feeling by throwing myself into the work. I set up the large geometric forms of the portrait—the egg head, the thick slanted pipe of the neck, the big triangles of the shoulders, and the forward swell of the pectorals with large slabs of clay slapped onto the armature to give the feeling of a body. I work very rapidly establishing all these shapes in about fifteen minutes. This roughing in of the basic shapes gets me going and gives me the momentum I need to really concentrate on refining the portrait. If you run into this same problem, you might want to try this technique for getting started.

THE NECK AND SHOULDERS

1. I start with a slab of clay wrapped around the armature to indicate the slant of the neck column.

2. I add a coat hanger shape at the back to represent the trapezius muscles.

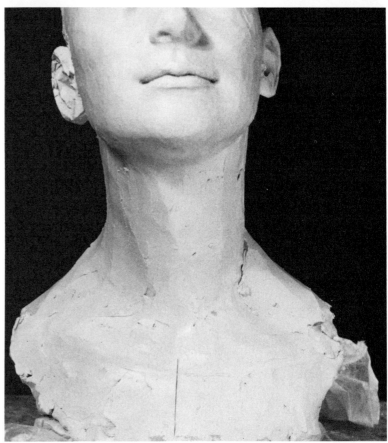

3. Next I rough in the collarbone and the pectoral muscles at the front, and check the width of the neck in comparison with the width of the jaw. I dig out a little hollow for the pit of the neck between the collarbones.

4. Turning again to the side, I develop the shape of the muscles down the side of the neck and the hollow between the neck, the collarbone, and the shoulder muscles. Then I improve the curve of the upper spine and the profile of the throat.

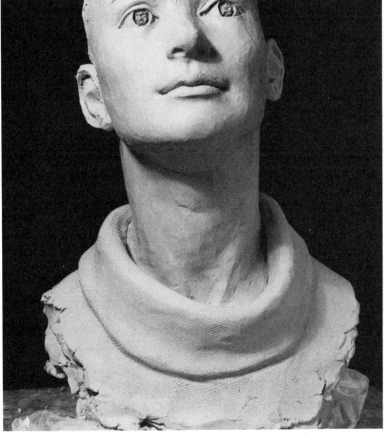

5. Last I add clothing that expresses the subject's style. Without the underlying structure the clothing would not appear convincing.

CHAPTER 4

CAPTURING THE SUBJECT'S PERSONALITY

In this chapter I will discuss ways of getting to know your subject better and capturing his or her personality characteristics, mannerisms, and style of dress. I find that one of the most pleasant aspects of being a portrait artist is having the opportunity to get acquainted with persons I might not otherwise meet. For the sitter, it's an unusual occasion away from the routine of work or school. After all, having your portrait made is like being entertained at a performance. With worries and preoccupations set aside most people blossom to reveal their most appealing qualities when they are the center of kindly and interested attention. They come to you expecting to enjoy themselves, and they usually do.

You wouldn't be a portrait artist if you were not interested in others, so you will find this situation suits your natural inclination and your present purpose perfectly.

I find that I have to complete the modeling of one portrait before starting another because I become so immersed in one personality that it is very difficult to pull out and consider another before the first work is resolved.

When I had finished the portrait of Josh, he came along with his younger brother, Jon, for Jon's first modeling session. I had to be careful not to look too closely at Josh that evening, so that Jon's portrait would not be influenced by Josh's personality. There was the great advantage of being able to watch the two play together with clay in a

completely unselfconscious manner. That was fine entertainment for me, and while I worked it reinforced the impression of Jon's individuality.

I think about the person whose portrait I am making and the design of the sculpture before falling asleep at night, while taking a shower, or cooking a meal. By the second modeling session, the person's features have become so familiar to me, that I can work almost without thinking. My hands seem to know just where to go to create the forms. It is this concentration on one person that gives the portrait its genuineness. I think if I tried to have two portraits going at once, scheduling modeling sessions alternately, they would not be convincing portrayals. They would just be human heads of a certain physical type.

RELAXING THE SUBJECT

The best way to relax your sitter is to start by simply asking about the subject's personal interests. Then watch the body language and facial expressions that accompany the reply. Every once in a while ask another leading question. In the meantime, continue working while your subject talks. The longer this continues the more your subject will feel welcome and relaxed, and the closer you will come to the real person.

The portrait sculptor has a great advantage over the portrait painter, since this process of getting acquainted can continue throughout the visit. Sitting silent and still is not required.

POSING THE SUBJECT

For a painted portrait it is necessary to find a pleasing arrangement of the figure and background or attitude of the head in relationship to the light. This is not an objective with a sculpture portrait. You are concerned with characteristic attitudes, it's true, but you must see every side of the head. The attitude need not be selected at the very beginning. For a little while at least the armature and clay can be moved to a slightly different pose as you become more familiar with your subject's habitual posture. So you don't say, "Please tilt your head a little this way." Instead you watch and wait to see what is the most characteristic tilt of the head or lift of a shoulder. After that is determined, you might want your subject to assume a specific pose for a moment to note the stretch or compression of the neck muscles, the fall of the hair, or any other significant detail. But this is not at all the uncomfortable experience of having to hold a pose for fifteen minutes or more as is often necessary for a painted portrait.

INVOLVING THE SUBJECT

You will find no strategy for involving the adult subject is needed. There is a natural interest in most of us to see how we are perceived by others. I have never had an adult subject who was not curious about how the likeness developed and about the whole process of modeling clay. However, many people are hesitant to offer suggestions for fear of offending me. I must explain that I value highly the sitter's criticisms. I tell my sitters that I not only want, but need their observations on any aspect or detail of the work. Each of us perceives the world differently and each of us notices different details. If we pool our perceptions, the work is enriched.

With a little encouragement, all of my adult subjects, as well as the parents who accompany children who are to be the subjects, become comfortable with the idea of criticizing the work. They become thoroughly involved and take personal pride in the progress made. The sculpture becomes truly a product of their powers of observation as well as mine. Some are much better at observing than others, but without exception they have all had the pleasure and satisfaction of seeing keenly and some perhaps more keenly than ever before. That is an exciting experience. Having one's portrait painted is a passive activity. Having a portrait sculpture made by this method is an active one and hard, satisfying work. There is nothing that makes the client appreciate the work more than taking part in making it.

Children, on the other hand, are usually so caught up in playing with the clay I give them that they take only occasional interest in the portrait itself.

CHILDREN

It is just as well that children are engrossed in their own activity, because in such circumstances they are more likely to behave in an unselfconscious way and reveal to you their most characteristic mannerisms.

Fortunately for the sculptor, playing with clay is one activity in which children seem to have an especially long attention span. It gives children endless pleasure and stimulates their imagination more than commercial toys do. There has been only one exception to this in my experience. That was a little girl who was afraid to get her hands dirty. I felt very sorry for her, but solved the problem by giving her crayons and paper. She wrote her name very neatly in different colors and sizes for an hour or so and then was ready to go home.

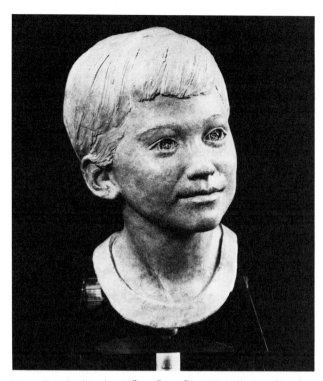

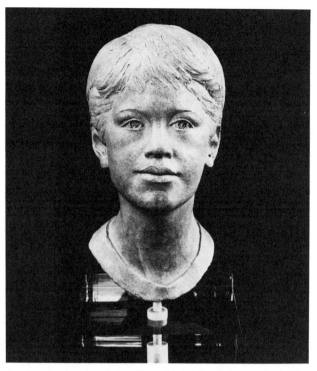

Mattie, Danish white clay, 13"h x 6"w x 6"d, 1980, collection of Stephen M. Solomon. This is Josh's little brother (Josh is the subject of a demonstration in chapter 5). The portrait is mounted on a base ¼" thinner than the one used for Josh, so that the smaller boy is posed glancing up toward the oldest one.

Jon, Danish white clay, 14"h x 6"w x 6"d, 1980, collection of Stephen M. Solomon. This is Josh's big brother. His portrait is mounted on a base ¼" thicker than the one used for Josh to emphasize the difference in age among the brothers.

ADULTS

You will find it very helpful to study an anatomy textbook in order to learn where to look for evidence of the various bones and facial muscles that give the head its contours. A specialized and very helpful text is the *Atlas of Human Anatomy for the Artist* by Stephen Rogers Peck (listed in the bibliography).

As a person ages it becomes easier to see the arrangement of bones and muscles beneath the skin. The more accurate you can be in placing the bulges and depressions, the more convincing your work will be.

Knowledge of the anatomy of the head is not only useful for portraying thin individuals or those of normal weight, but it can be quite useful in making a portrait of a very fat person because the bones over which the fat is draped help determine the surface curves of the adipose tissue. By understanding the underlying structure, you have a better chance of placing the shapes in the right places and, therefore, of creating a convincing likeness.

Faces marked by life are the most interesting ones to model. The pattern of lines and the expression are determined not just by anatomy but also by the individual's response to the conditions of life. There are smile lines and

worry lines, as well as friendly expressions and hostile ones. The habitual expressions help form the adult face and the effects increase with age. When it is said that a portrait "captures the soul of the subject," the artist has recorded accurately the individual's general attitude toward life in the contours of the face. Clearly, a study of anatomy is not enough. It is only an aid to keen observation and careful recording.

FLATTERY

A portrait would not be commissioned if the person ordering it were not interested in a faithful representation of the subject. The subject's appearance may not be appealing to you, but it is important to your client. Once I tried to minimize one feature that seemed undesirable in a portrait. My client pointed out that this feature was not accurate and spoiled the likeness. Of course, I corrected it. Sometimes it is even desirable to exaggerate a characteristic in order to increase the strength of the statement about the person. A good example of this is John Singer Sargent's portrait of *Coventry Patmore.* It gives a very strong impression of the man's character. However, when you com-

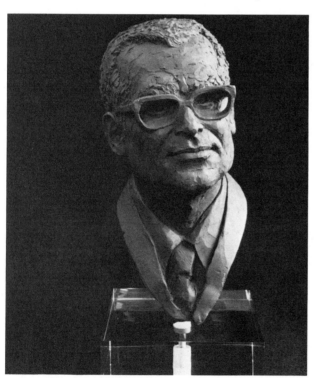

Don, Danish white clay, 14"h x 6"w x 6"d, 1980, collection of Mr. and Mrs. D.S. Grubbs, Jr. This is a pretty good likeness of my husband, who is a very nice subject for modeling. His muscles are well formed, there are deep contours at the corners of the mouth. The crew cut reveals a well-shaped head. After the piece was mounted I noticed that the rather sharp point at the bottom of the coat collar is out of character with the rest of the sculpture. There should have been more indication of muscular shoulders and a broad chest to match the sturdy head.

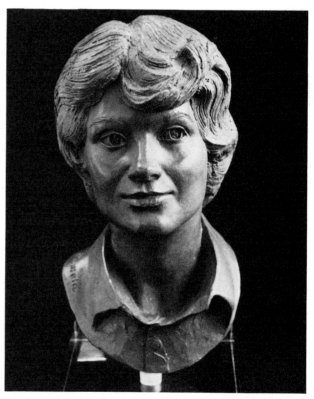

Pamela, stoneware, 15"h x 6½"w x 6½"d, 1980, collection of Pamela and Richard Halstrick.

This portrait shows all the features that were demonstrated in chapter 3 together. Pam's face is so pretty that she provides a good, clear example for . every part of a portrait.

pare it with a photograph of the subject you see that the artist has lengthened Patmore's neck considerably and reduced the scale of his clothing. The painting borders on caricature and is more expressive because of that.

In general, I believe that flattery, by making an unusual face more conventional, weakens a portrait, but that slight exaggeration of carefully selected features can strengthen it greatly. What would you exaggerate? Whatever it is that you feel intuitively will strengthen the statement you wish to make about your subject. This may not seem to be a satisfactory answer to the question, but it will acquire meaning for you as you gain experience. For example, I would not exaggerate overweight and might even minimize it slightly, but the craggy features of the mature man might be exaggerated slightly to good effect.

PROPS AND COSTUMES

A painter has the advantage of introducing many props into the composition of a portrait—pets, toys, still-life objects—to provide information about the sitter's interests and personality. Unfortunately, there is very little room for that sort of thing in portrait sculpture. However, there are opportunities to include elements that tell a lot about an individual. You might, for example, portray Cleopatra as a beautiful woman with an asp around her neck; or like Stanley Bleifeld, create a memorable portrait of a young girl by showing her playing the flute.

Although you are dealing primarily with the head, it is possible to make a telling statement about the sitter by including such small details as a collar or a particular type of earring. A certain style of necktie with a suggestion of the design incised in the clay would add to the sense of one man's personality, just as an open shirt would for another man. Sometimes, the simple edge of a T-shirt is all that is needed to set off a delicate child's face. Again, a particularly engaging facial expression might require having no props at all, since they might distract from the face itself. You should be alert to this possibility and be sure not to add so much detail that it works against the real focus of attention.

One of my earliest subjects almost always wore pop-it beads. The finished edge of her portrait was a string of beads of that type. In this way, something characteristic of her taste became an important part of the final design. The miniature portrait of *Tila Maria* (page 14) is enhanced by her customary soft and ruffled collar and bow. Hair ornaments, like the chopsticks in *Lois James's* hair (page 126), convey a great deal about her personal style. If you can

(following page) *Chesapeake Waterman*, earthenware, 24"h x 16"w x 10"d, 1980, collection of the artist. Photo by Joel Breger.

Here the theme is man against the elements. The face is rough, the eyes deep set and farseeing, the surfaces of coat and hat slick, the attitude one of a man accustomed to challenging nature unafraid. The base is a slice of weathered oak wih an ebony stain. The most difficult part of making this sculpture was getting the brim of the hat to dry without cracking as it shrank. I covered the brim thoroughly with plastic wrap while the rest of the piece dried slowly, sucking water from the brim. I checked the brim daily, mending at once any cracks that appeared in spite of this treatment.

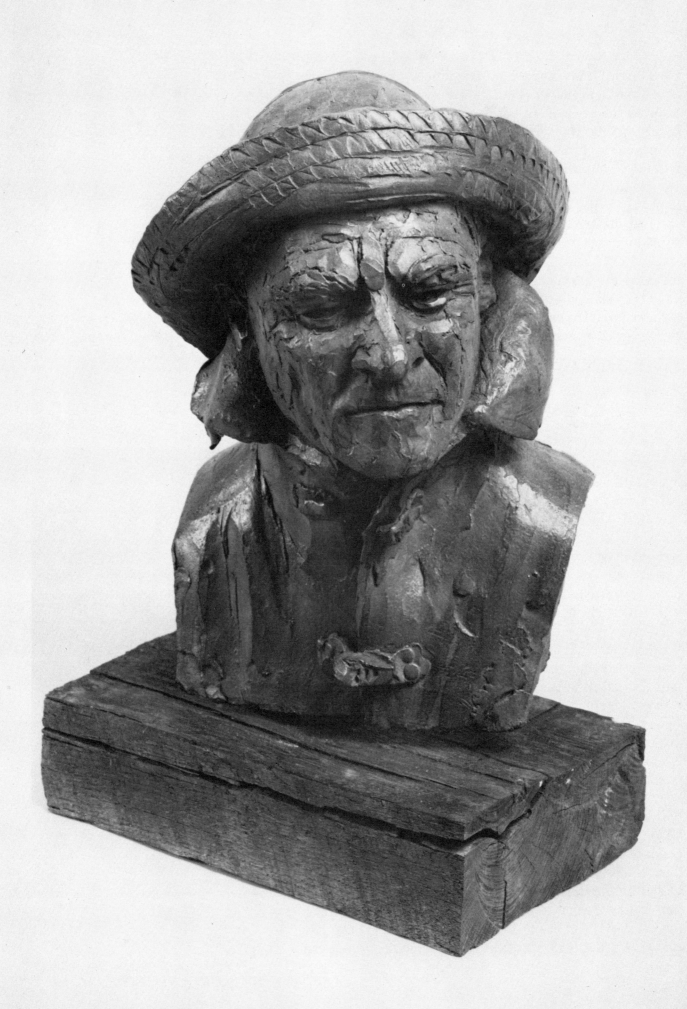

think of something along these lines, which fits the limitations of your format, it will indeed add interest and expressiveness to the work.

BEARDS AND MOUSTACHES

When your subject has a moustache or beard, it is a sound idea to model the face as though it were clean shaven first. In that way you can be sure that the moustache or beard has a convincing bone structure beneath it. After the face is modeled, notice the overall volume and shape of the facial hair and superimpose it on the face you have made. Each moustache and each beard not only has the shape to which its owner has trimmed it, but also has a unique pattern of hair growth. Try to indicate this by adding texture to the surface at least in a general way. Again, do not try to model each individual hair on the surface of the form. Study the first demonstration of the portrait of *Richard* to see how I developed one particular moustache.

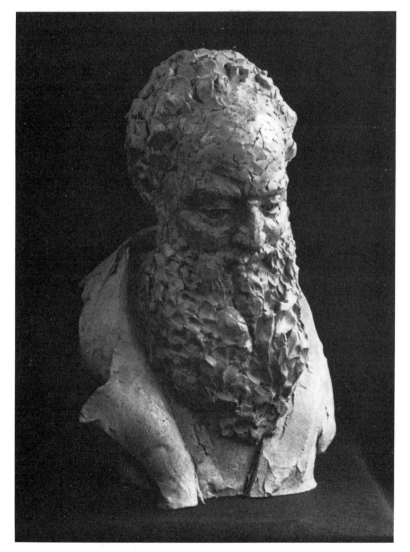

Bearded Man, terra-cotta, 20"h x 13"w x 10"d, 1977, collection of the artist.

The most memorable phase of making this sculpture was hollowing it out. I rushed to do the job too soon. The head and beard were almost entirely hollow when suddenly the piece collapsed all around the edge of the beard. The clay was still a little too soft and I had cut too close to the line where the beard met the clothing. I spread one hand wide inside the face to hold it up and wildly grabbed chunks of clay with the other hand, jamming them inside the sculpture to shore it up. It was an anxious fifteen minutes until the piece was stabilized.

HAIR

Hair should be considered not as a collection of individual hairs but as a volume or series of volumes of a particular shape and size. When you're studying the sitter's hair, notice its length in relation to the chin, the ears, and the collar. Notice whether it puffs out much wider than the tips of the ears or lies flat against the head, perhaps even allowing the tips of the ears to show between parted strands. It is especially important to look at the side view and see how far the hair protrudes in front of the forehead. Does it go as far forward as the tip of the nose? Just as you do with a beard or moustache, you must notice the general direction of the growth of the hair.

Another factor to consider is its color. Even though color is not realistic in sculpture, you can produce the effect of dark hair by brushing the surface with very rough tools, making a deeply incised texture. You might use a paint paddle for this. Heavy texturing creates shadows that give the impression of dark hair. You would model blond or white hair with a much smoother surface so that it catches the light and minimizes shadow.

Be very careful about the design of hairlines around the face. Blend the hair into the skin in some places around the face to minimize its edges. Otherwise the hair is apt to look like a wig.

Be attentive to the location and shape of any bald spots and the way in which the hair meets the edge of the bald area—either lying flat or rising at a steep angle from the scalp. Some bald areas show a ridge of bone beneath. Modeling the exact shape of this is helpful in achieving a convincing likeness.

GLASSES

It is better not to do a portrait sculpture with glasses if it can possibly be avoided. First of all, it is difficult to model the frames. In my portrait demonstration of *Sarah* (pages 127–131), you can see one way of doing this, but it does require nimble fingers and patience. Because the frames are thin, they break easily and it is terribly hard to get both sides to hold the same shape. Also, the clay of the frames dries faster than the face they are attached to, so they shrink and crack. You have to keep spraying the frames to equalize the rate of shrinkage while the rest dries.

A bigger disadvantage of making a portrait with glasses, however, is dealing with the distracting shadow they cast on the face. As a result, when you look at the portrait you see the glasses before you see the person. One

way to minimize this problem is to blend the lower edge of the rims into the face and also use a very dark patina to de-emphasize the shadow.

Of course, there are some people for whom glasses form an important part of the likeness. In these cases you will just have to do the best you can.

SKETCHING A PERSONALITY IN CLAY

Among the following photographs you will see three categories of work. First are the quick sketches of individuals such as *Freud* and *Einstein*. These abstract certain qualities of the original countenance and emphasize them. The modeling does not go into precise detail as a formal portrait does. Doing sketches like these helps you to see those qualities that contribute most to a likeness. You might find it useful to do a quick sketch first of someone of whom you intend to do a serious portrait of later.

Next in order of abstraction are the caricatures such as *Coventry Patmore*, the man in the turtleneck sweater, and the sax player.

The cartoon figures are the most abstract of these three groups. The emphasis in them is on the essential lines and gestures.

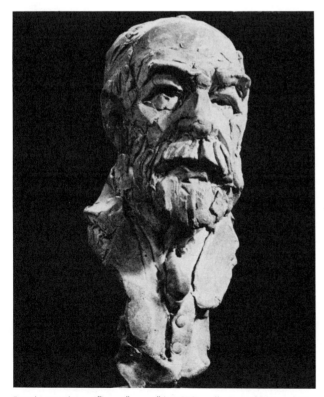

Freud, porcelain, 6"h x 4"w x 4"d, 1979, collection of Dr. and Mrs. Michael F. Lapadula. Photo by Rae Zapata.

When I made this one everyone in our family was reading a book about subliminal advertising. The children suggested I embed some words in Dr. Freud's beard and hair. That was fun. Can you find any of them?

Einstein, porcelain, 6"h x 4"w x 4"d, 1979, Turner Collection. Photo by Rae Zapata.

I love this little figure of Dr. Einstein with his hands clasped behind his back as though he were pacing back and forth deep in thought. The modeling is extremely loose. The clay was very soft and easy to push around.

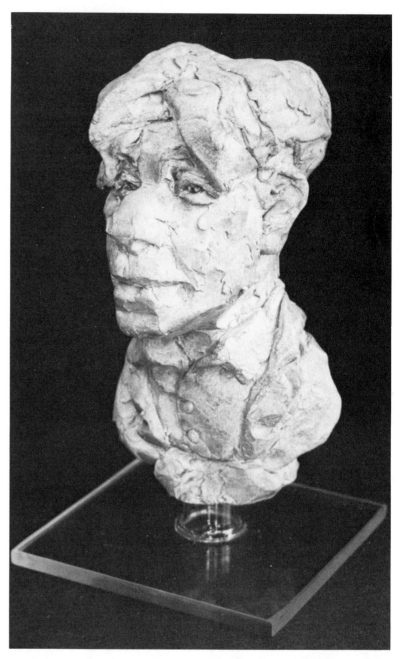

Boris Pasternak, porcelain, 7"h x 4½"w x 4½"d, 1979, collection of the artist.

Here is Boris with his coat pushed back and his hands in his trouser pockets looking tousled and serious. When you work this small it is possible to get the gesture of the figure as well as the head, providing a fuller expression of the personality.

(opposite page) *Coventry Patmore*, porcelain, 7½"h x 4½"w x 4½"d, 1979, collection of the artist. Photo by Joel Breger.

John Singer Sargent's portrait of Patmore excited me because of his almost caricatured interpretation of the subject. Using very soft clay, I have carried the caricature still further. The clay flows so freely under the tool that a very crisp and active surface results.

It is a valuable exercise to reduce the figure to its essence and note the rhythmic repetition in the parts: active, passive, muscular, soft, bulky, skinny, tapering, or chunky. Working in this small scale you can get the gesture of the figure as well as the head, giving wider scope to your interpretation of the personality.

When you return to doing serious portraits there will be a carry-over from these lessons. You will be even more aware of the way in which hairstyle, bulk or softness of clothing, and jewelry augment and repeat similar qualities in the facial features. You will become ever more alert to the uniqueness of any subject you choose to model. This is absorbing and relaxing entertainment, too.

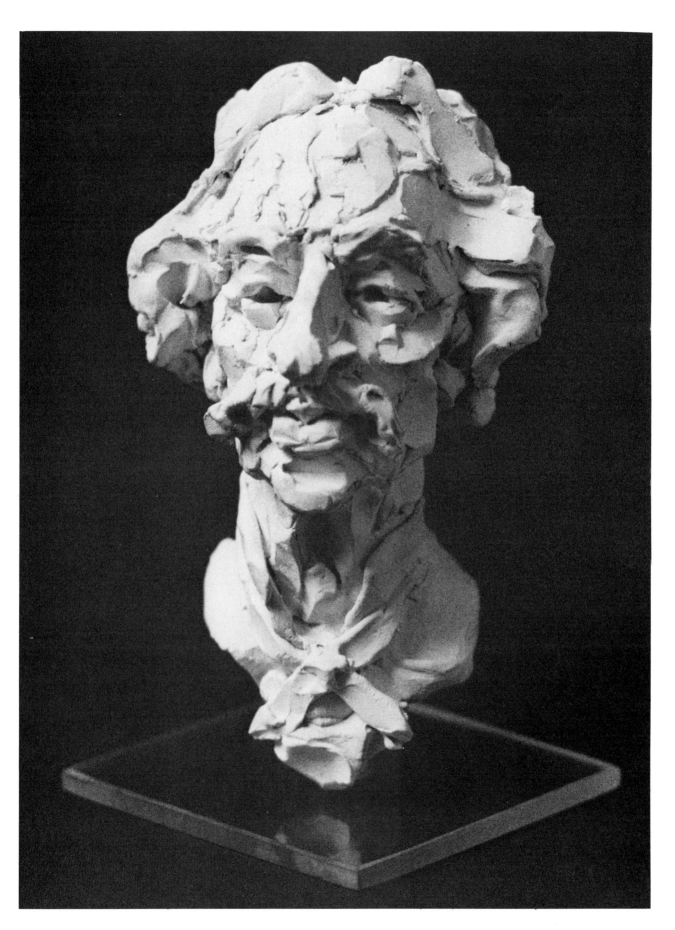

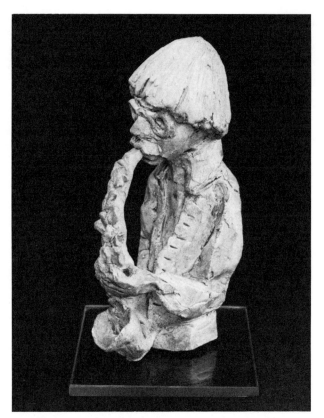

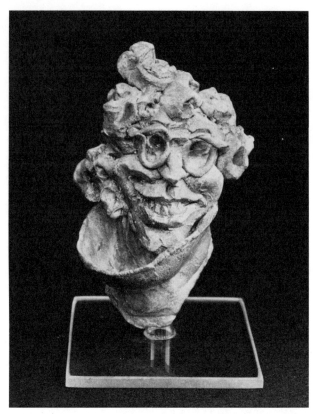

Sax, porcelain, 7"h x 4½"w x 4½"d, 1979, collection of the artist. The player and the instrument lean toward each other and merge. The buttonholes on the vest provide a counterpoint to the crazy knobs on the horn. The face is introspective, listening. Watch how anyone's body is used in action and file these bits of information in your mind.

Turtleneck, porcelain, 7"h x 4½"w x 4½"d, 1977, collection of the artist. This was done without a particular person in mind. It was a matter of throwing together a collection of features with all the necessary planes and curves and then adding hair and clothing that seemed to be in character. It's good exercise for loosening up your technique.

(opposite page) *Victoria*, porcelain, 7"h x 4½"w x 4½"d, 1979, collection of the artist. The idea for Victoria came from a photograph made in the 1890s of a group of ladies at a lawn party. The face was modeled in five or ten minutes. The brim of the hat was made by rolling out a piece of clay between two pieces of terry cloth. After removing the cloth, a hole was cut in the middle of the clay and the edges torn to form a rough circle. Then it was pressed down over the crown of the head.

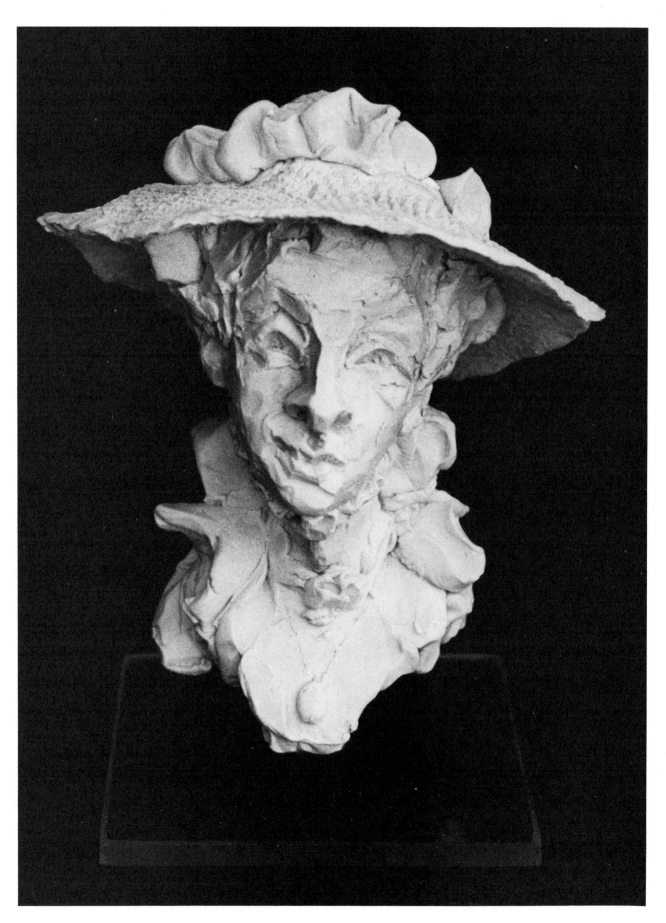

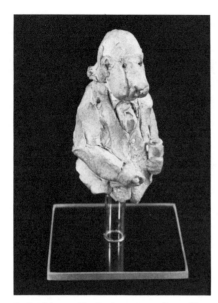

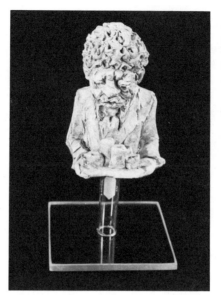

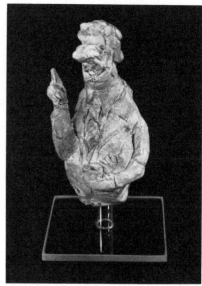

Cocktail Party: The Professor, porcelain, 6"h x 4"w x 4"d, 1978, collection of Judith and Don Galloway. In this figure I emphasized the repeating droop of the nose, jowls, and paunch of this passive character with his long hair, cigar, and highball glass. The tie droops, as do the points of the vest, as well as his eyes.

Cocktail Party: The Host, porcelain, 6"h x 4"w x 4"d, 1978, collection of Judith and Don Galloway. The host's shoulders are drawn up with tension as he concentrates on not spilling the drinks; his eyes bulge with the effort. Here you can see the base quite well. It is a square of ¼" plate glass with a test tube glued onto it.

Cocktail Party: The Lecturer, porcelain, 6½"h x 4"w x 4"d, 1978, collection of Judith and Don Galloway. This individual is pointing his nose, his finger, and his wide open mouth at whoever will listen. His coat collar and tie are as loose as his mouth. The hair is just lumps of clay pushed onto the head. Much of the modeling is accidental. When it works, let it be.

Cocktail Party: The Lecher, 6½"h x 4"w x 4"d, and *The Sweet Young Thing,* 6"h x 4" w x 4"d, 1978, collection of Judith and Don Galloway. The pieces in this group are intended to be moved around to form various relationships.

CHAPTER 5

STEP-BY-STEP
DEMONSTRATIONS

In this chapter I have selected six different models as my subjects. I will demonstrate how to model each of these heads following the basic sequence outlined in chapter 2. Each subject was selected to represent a different type of head that you may model someday and to present special problems with hair, glasses, and other accessories that you may encounter.

These demonstrations are intended to direct your attention to a few of the differences of age, sex, and race. You could spend a lifetime studying the variations of the human head. This chapter simply alerts you to the kinds of differences that occur.

For the first demonstration I model the head of a very young white boy; in the second, a young oriental boy. The third demonstration is a portrait of an adolescent girl with very long hair; the fourth is a demonstration modeling the head of a young black woman; the fifth, a woman wearing glasses, and the sixth is a portrait of a mature man.

MODELING A YOUNG CHILD: JOSHUA SOLOMON

This young man is six years old. During the conference with his parents about his portrait, they decided it should be scaled at eighty percent of life size. I encouraged this because I think that it is a particularly good size for a portrait of a young child. I recommended to them that we use Danish white clay, which fires to white, so that any finish we selected would not be altered by the color of the fired clay.

I photographed and measured Josh one afternoon and made a date for the first modeling session three weeks later to allow time for developing and printing his pictures and for the preliminary modeling.

I had no trouble working from the photographs, but when Josh himself appeared I thought, "This child is so beautiful. How do I dare to try to make his portrait?"

Josh was an ideal subject. He played with clay quietly, showed an interest in the developing portrait, and was very cooperative when asked to look up or turn his head. Josh's father brought him to the first modeling session and commented that he valued the opportunity to be with his children one at a time. They played with clay together while we all worked on the portrait. Josh's mother brought him to later sessions, so both parents had a share in the development of the portrait. Together we made a nice little head. There is an air of wistfulness about Josh that I think has been expressed in the portrait.

There are certain characteristics of a child's head that differ from those of an adult. The infant's head is mostly cranium, the face being tucked into the bottom third of the head and showing no jawline. As a child develops, the face grows faster than the cranium. The jaw drops from the level of the ears and shows an angle, the brow ridge ap-

pears, the nose begins to show a family resemblance, and the corners of the mouth no longer droop as much as in the sucking pose of the infant. The pads of fat in the cheeks gradually disappear, and the neck thickens in proportion to the head. By the time adult status is reached, the ratio of head to total height has changed from one to four to become one to about seven-and-one-half with proportional changes in width as well. The infant's shoulders are not very much wider than the head, whereas an adult's shoulders are about two heads wide. All of these changes take place gradually and at varying rates, so you will have to observe your subject closely to see what stage of development has been reached.

Please notice in the photographs that at every stage of the work's development there is something of the subject's character evident in the form. In steps 1 and 2, even though the proportions are wrong, you can see the characteristic tilt of the head and a suggestion of slenderness. These two photos show my first rough guess at the proportions of the head. This was made just to have something to build upon using the dimensions on the chart.

In steps 3 and 4 you can see that I had been doing so many adult portraits that I had become accustomed to adult proportions. I had to add a large amount of clay to the cranium to bring it into proper proportion with this child's face.

In steps 5 and 6 you begin to see the shy expression of the face even though the features are still at a very crude stage of modeling. I think this effect is a result of a combination of the tilt of the head, the downward glance, and slight smile.

At every stage I work on the whole portrait. One feature is not finished in advance of the others. In steps 7 and 8 you see that each facial feature, the hair, ears, neck, and collar are all at about the same stage of development. What they all still lack is a rounded fullness contrasted with deep undercuts.

Compare step 9 with step 11 especially around the eyes and mouth. See the difference in the gently swelling flesh and in the curve of the forehead in profile. In the finished portrait the smooth, simple collar is in harmony with the clear soft forms of the face.

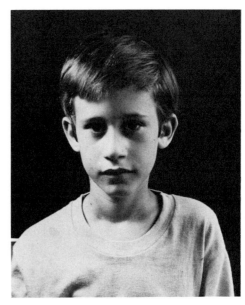

Notice in this front view of Josh his deeply set dark eyes, small delicate face, full mouth, and slender neck.

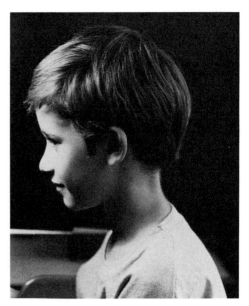

The side view shows the relationship of the small facial structure to the relatively large cranium typical of a young child.

Step 1. Here is a quickly modeled oval head shape on which I will build the portrait.

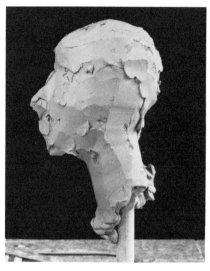

Step 2. This rough shape is the core for the head as I measured it and scaled it down in size by 20 percent (80 percent of life size).

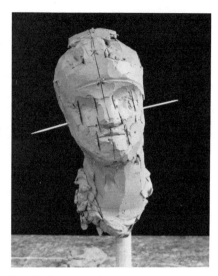

Step 3. You can see the proportions I set up are not those of a small child. I had gotten into the habit of doing adults and had to adjust for the differences.

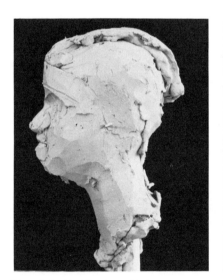

Step 4. In this side view with the proportions corrected, the relationship of the child's small face to the rest of his head is especially clear.

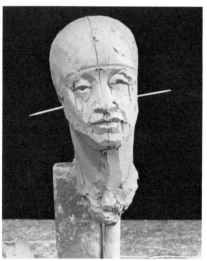

Step 5. I model all the features in a sketchy manner to establish their proper size and their placement.

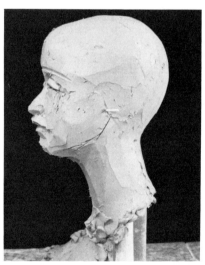

Step 6. I check the side to see that the face is not flat and the eyes are set in properly.

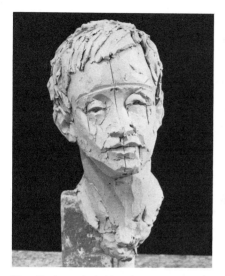

Step 7. Again I develop the portrait evenly, bringing each part of the portrait to the same degree of finish before moving to the next stage. I study Josh carefully and correct or elaborate small details over the entire sculpture. The upper eyelids, the curve from them up over the brow, the nostrils, every curve of the mouth and chin, the eyebrows, the shape of the hair, and the collar must all be refined. The eyeballs, the ears, and the length of the neck must be attended to also.

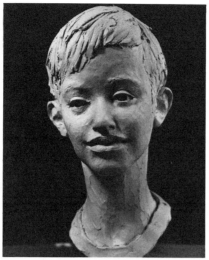

Step 8. Here we are approaching the final stage of modeling.

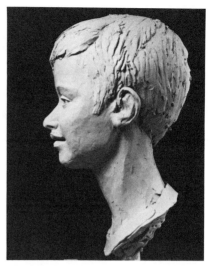

Step 9. In this side view you can see that the incurvature at the top of the nose and the brow is too deep. The whole forehead needs to be brought forward.

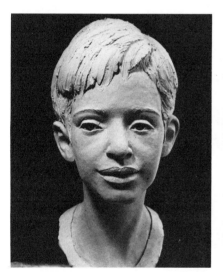

Step 10. At the end I concentrate on filling out and rounding all the forms to give the flesh an appearance of softness.

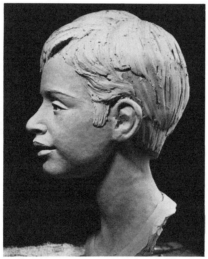

Step 11. The pose looking down and to the side makes the eyelids show more than they do in the photographs of Josh. The neck is a little longer than the real one in order to emphasize the child's slenderness.

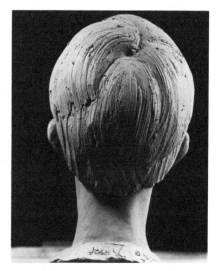

Step 12. I try to make the back of the head interesting by dividing the hair into sections forming an active pattern.

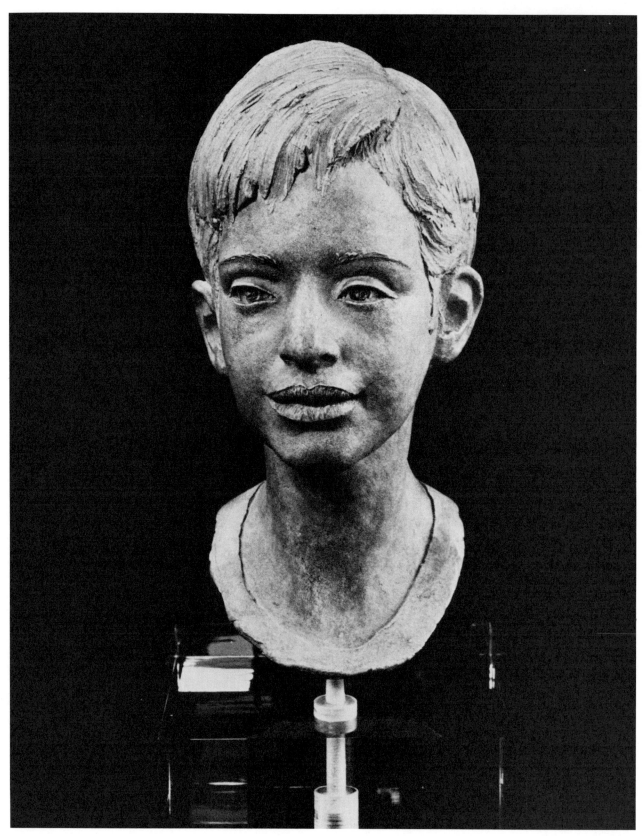

Step 13. I give the portrait a pale golden bronze finish. For the patina I use a little burnt sienna with white in the shellac coat, yellow ochre in one wax coat, and green earth in the next. The objective was to make it look like bronze but very pale for a delicate child's face. The finished piece is mounted on Plexiglas.

Josh, Danish white clay, 12"h x 6"w x 7"d, collection of Stephen M. Solomon.

DEMONSTRATION 2

MODELING AN ORIENTAL CHILD: ARIC INGLE

This young man was born in Thailand and has the lovely almond eyes of that race. His wide face, full round mouth, small wide nose, and glossy, straight black hair are all characteristics associated with oriental peoples. The scale for this portrait was eighty percent of life size.

Aric came to the studio with his mother, brother, and sister for the photographing session. Before the camera he assumed a dignified and serene pose without any coaching. As soon as the camera was set aside he resumed his playful activities with his siblings. For the single modeling session there were only Aric and I together in the studio. Aric made a fantastic landscape with his pile of clay. He carried on an imaginative monologue about the creatures he was making and the history of the place he had created. He seemed completely absorbed, but whenever I glanced at him he straightened up and assumed the dignified pose.

The important elements of this composition are the three major forms of the hair, the face, and the neck as simplified geometric shapes. Established as elementary volumes in proper relationship to each other, they express the general character of the portrait. Each form can be elaborated upon later to make the likeness more specific and to enrich the overall design of the sculpture.

I started this portrait in the usual way, by establishing the dimensions and the pose, then refining the face before adding the hair. The initial impression of the hair is that it is

a simple hemisphere. Closer study reveals deep shadows indicating subdivisions of the general shape. These subdivisions suggest the means for enriching the design of the hair and for guiding the observer around the sculpture. One object is to lure the viewer's eye to linger, to remain interested in seeing the work more intimately.

Steps 6 and 7 show how far I develop the work by using just the chart and the photographs.

When Aric came to the studio for the modeling session, I saw at once that I had made the nose too long and narrow, the eyes too small, and the mouth not full enough. We spent two hours together making these corrections and lowering the bangs over his eyes. Then it seemed to me that we had accomplished what we had set out to do. I did not want to add a collar. I felt that in this case it would distract from the objective rather than add a nice finishing line.

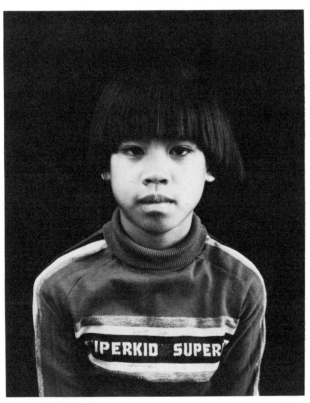

The first thing I notice about Aric is his dignity. His direct gaze and the solemn pose he assumes without being told are the keys to the design of his portrait.

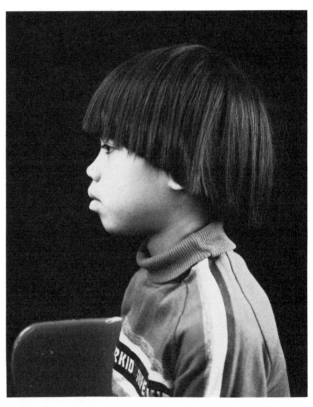

The side view shows the beautiful geometry of the hair, face, and neck that will be the three major forms of the sculpture.

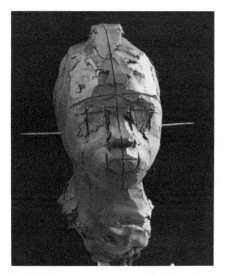

Step 1. Here you see the size established and the locations of the features marked.

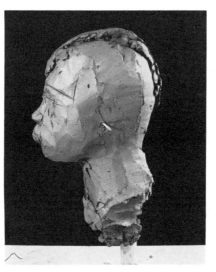

Step 2. From the side it is already possible to see the overall roundness that will characterize this portrait.

Step 3. I mark the midline across the top and down the back of the head checking to see that the x at the middle of the back of the head is equally distant from both ears. This line helps me to see that the two sides of the cranium are equally filled out.

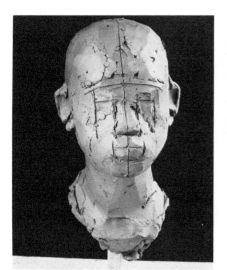

Step 4. I add crudely modeled ears and fill out the cranium and some of the facial contours.

Step 5. Next, I shape the back of the head and improve the direction of the thrust of the neck.

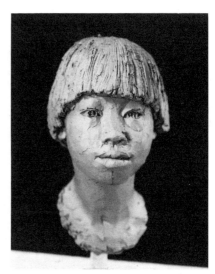

Step 6. I develop all of the facial features equally and begin to build the mass of the hair.

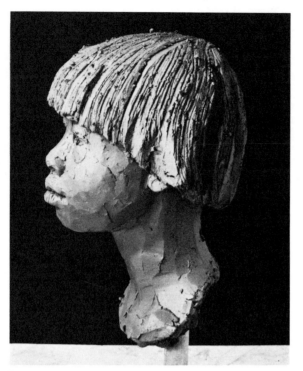

Step 7. In the side view you can already see the final plan for the sculpture, although none of the shapes is accurate yet.

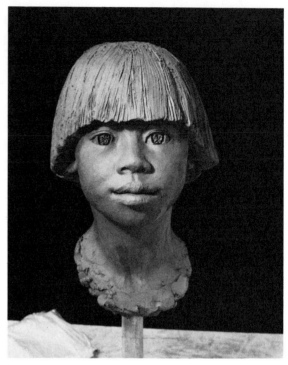

Step 8. During the modeling session with Aric, I correct and refine features. I study every curve of the mouth, nose, and eyes to see how each curve fits into the next one. I turn the sculpture stand extremely slowly to follow with my eyes every bulge and hollow as well as the transitions between them. I peel a little clay off here and add a little there, turning the sculpture slowly to be sure the new contour blends into the rest.

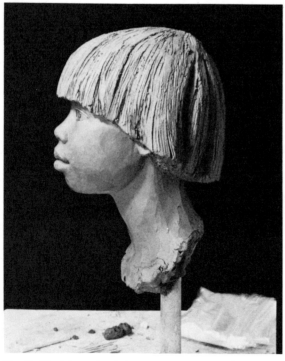

Step 9. All of the major design components are now in proper relation to each other. I give the hair a more interesting design by making it bulge over the ears and fall closer to the head behind the ears.

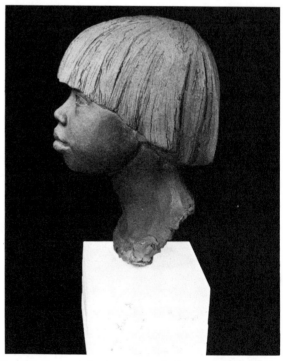

Step 10. The patina for Aric consists of a first coat of shellac and alcohol with mars violet and viridian, making the hair and eyes especially dark. In fact, I put two coats of this on the hair and inside the eyes. Then I add a coat of Krylon spray paint in a color called ruddy brown, followed by wax and graphite. Last I mount the portrait on a base made of laminated slabs of artificial marble.

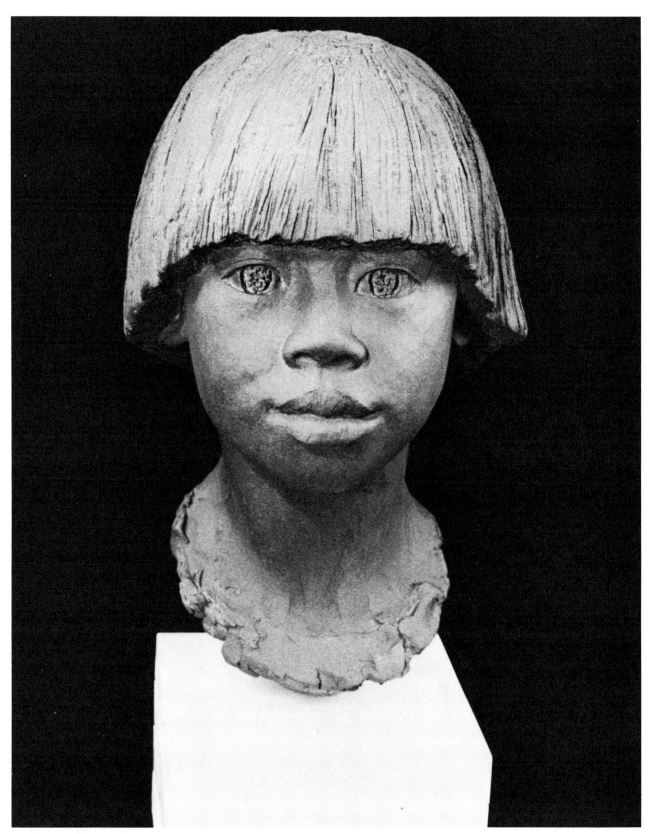

Step 11. Front view of Aric finished with the sculpture complete.

Aric, stoneware, 12½"h x 6"w x 7"d, collection of the artist.

MODELING
AN ADOLESCENT GIRL
WITH LONG HAIR:
CATHY COFFIN

This portrait of a young girl presents two special problems—one is the modeling of very long hair, and the other, the inclusion of the base as an integral part of the sculpture.

At the time when I decided to do Cathy's portrait her hair came down almost to her waist and was curled only on the ends. I didn't want to do a half figure but I did want to include the gracefully draped hair and its characteristic straightness ending in soft rolls of curls. The solution which presented itself was to make the usual head, neck, and collar and have the hair cascade down beyond the collar over a pedestal. The easiest way I could think of doing this was to model the pedestal as part of the composition.

When the extension ring is installed on my kiln it is possible to fire a piece about 19″ high. I measured one of the other portraits before it was fired and found that it was 12″ high. If I made Cathy's head, neck, and collar in the same scale, at eighty percent of life size, it would be possible to add a pedestal $5\frac{1}{2}$″ high and fit it into the extended kiln for firing. It was on the basis of this calculation that I decided to do Cathy's portrait at eighty percent of life size. Whatever the length of Cathy's hair really happened to be, in this portrait it would fall just to the base of the pedestal.

I used a heavily grogged earthenware clay for this portrait, because I wanted it to retain a fluid modeling quality as long as possible while I played with the drape of the hair.

Cathy is very mature for her age and was a calm and patient model. Sometimes it takes a very long time to establish a likeness, as it did in this case. Not as much of the face shows in this portrait as in some of the others, so

the likeness in the part that does show is especially important. Cathy kept assuring me that she was in no hurry, that as long as we were doing it we might as well do it right. She volunteered to come back for an extra sitting, for which I was very grateful.

To begin this job I assembled an armature taller than usual to allow space for the pedestal. The vertical pipe is 10″ high. Then I made a guess as to how the volume of the head would be distributed above the base. I drew a circle with a pencil on the base of the armature. As you can see in step 1, that circle is not centered around the vertical pipe and collar, but is slightly forward. Then I began to build the pedestal rather like a coil-built pot using a template cut from very heavy cardboard. The pedestal is much thicker than a pot would be. This is because it has to have the weight of the head pressing down on it. I filled in some clay for a top to the pedestal to steady it against the pipe.

Next I modeled the head without any hair. Each feature is ripe, lush, and smooth. It is all too easy to become absorbed in modeling those full lips and forget about the overall relationship of the features. After the hair was started I stood back to view the work from a distance. It became apparent that the upper part of the face was not built far enough forward. You can see in step 9 that I had to add a good deal of clay to the forehead, brows, and bridge of the nose to bring that forward and to provide a sufficient frame for the eyes.

Just as an experiment, I tried making the hair in a rather art nouveau style. This was fun to play with, but it did not turn out to suit either the essential character of the subject's hair or my preconception of the composition. I gradually modified and altered it until it fit my idea.

Cathy came back for a final sitting. We worked on the face, with a section of hair cut away, until that was satisfactory. After Cathy left, I replaced the hair around the face.

Hollowing out this piece presented a more difficult job than usual because of its greater size and weight, and because it extended all the way down to the platform of the armature. The techniques are the same as those used in the demonstration of Richard's portrait. I cut off the back of the head to the level of the top of the pedestal and removed as much clay as possible, not only from the head but also from the pedestal. When most of the clay was removed and the head reassembled, I slipped a palette knife under the pedestal, and ran it all around the bottom of the pedestal to cut it free from the base. Then I carefully lifted the sculpture up off the pipes and set it down on the sandbags to finish hollowing out the lower part.

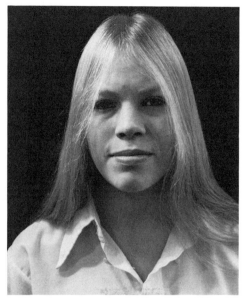

Cathy has a nice oval face and soft even features. Her lovely long hair is the commanding element in the design of her portrait.

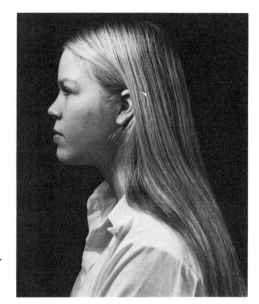

Cathy at sixteen is just about full grown. You can see that the relationship of face to cranium is quite different from that of Josh or Aric.

Step 1. This 10″ vertical pipe will raise the head enough to allow room for the pedestal I want to incorporate in the final design. I mark a circle on the base to indicate the off-center position for the pedestal and start building with a coil of clay.

Step 2. I build the pedestal to the approximate size, and then drag a heavy cardboard template around the surface to wipe off any excess clay. I work this way until the desired shape is achieved.

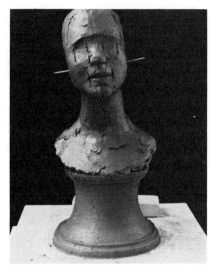

Step 3. I build the volume of the head by establishing the width from ear to ear first, and then by setting the length of the face according to the measurements, I mark in all the features, adjusting them to be sure they are well in front of the pipes and centered over the pedestal. I tilt the head a little to one side to give movement to the pose as I develop the neck and shoulders, attaching the portrait firmly to its pedestal.

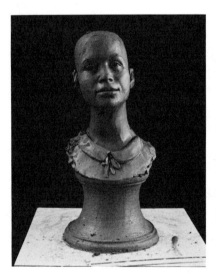

Step 4. I model the features and add her collar and bow before starting the hair.

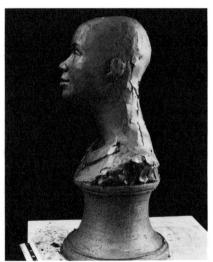

Step 5. This side view shows why the pedestal was built off center toward the front of the armature base. You can see that the mass of the head is carried forward so that the weight is balanced over the pedestal.

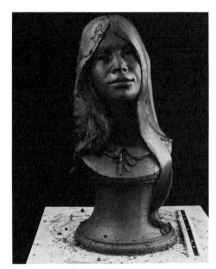

Step 6. I begin to design the hair. Since the head is tilted to the left the hair falls away from the face on that side and rests against the cheek on the right. I make big fat worms of clay and press one end to the scalp, experimenting with draping the rest and flattening it as required. Then I fill flat sheets of clay in between the long worms to provide a transition between the bulges. I continue to cut and fill and *brush* the hair until a convincing flow is achieved.

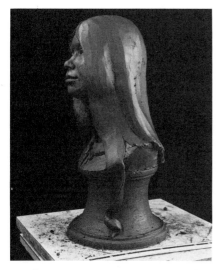

Step 7. It is necessary to show a bulge where the ear lifts the hair away from the skull and also to design the flow of strands of hair to help lead the viewer's eye around the sculpture.

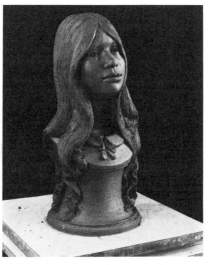

Step 8. I start making elaborate tendrils of hair intertwining down the sides of the pedestal but find the effect too busy.

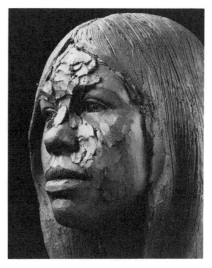

Step 9. With Cathy in the studio I realize that the brow of the sculpture is modeled too flat and the cheeks are not rounded enough. So I begin to remodel the face while I also remove some of those unnecessary curls.

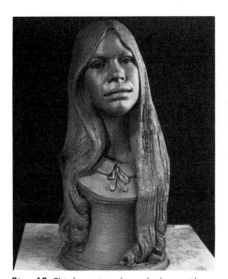

Step 10. This front view shows the brow ridge properly developed, the hair replaced over the cheek, and the curls redesigned to the style Cathy sometimes wears, soft curls at the end of straight hair.

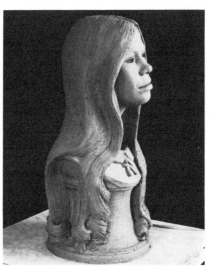

Step 11. I write the date, copyright, and my signature under the curve of the shoulder.

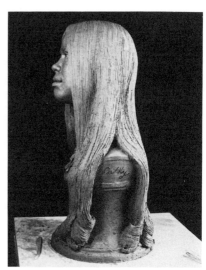

Step 12. Here you can see how the curls fall on the other side of the sculpture and the title inscribed under the curve of the shoulder.

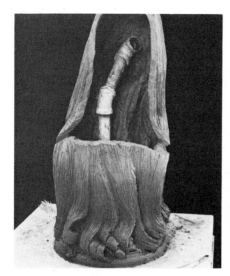

Step 13. The curls fall in irregular clusters across the back. This illustration shows the shape of the section I cut away for hollowing out the sculpture.

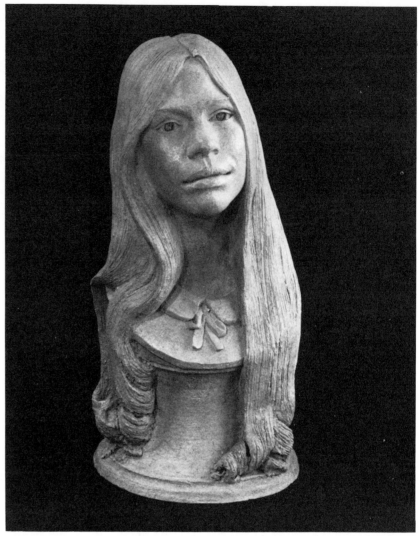

Step 14. The patina on this portrait is made of an antique white flat spray paint covered with several coats of wax in shades of pale terra-cotta and earth green. Cathy is a blond with fair skin. The patina does not match her coloring by any means but it does have a similar lightness about it.

Cathy, earthenware, 17"h x 8½"w x 8"d, collection of the artist.

DEMONSTRATION 4

MODELING A YOUNG BLACK WOMAN: LOIS JAMES

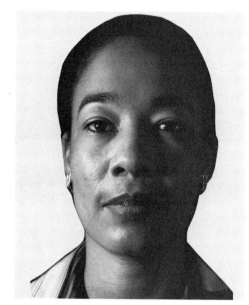

This clear, close-up frontal photograph of Lois reveals her unusual almond-shaped eyes and high cheekbones. I cut her photograph out and mounted it on white board so I could clearly see the contours of her head.

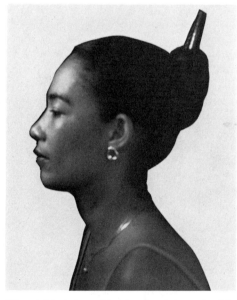

Although this photograph is not as sharply focused as I'd like, you can see the regal profile with beautifully balanced chignon and interesting accessories that inspired the design of my portrait. Again I have cut out her photograph and mounted it on a white card to highlight the profile.

Again, this portrait is scaled to eighty percent of life measurement. When I made this portrait I had just finished several others in stoneware clay, so I decided to use earthenware. This change of texture helps keep my hands sensitive to the feel of the clay. I often use earthenware when doing a portrait of a black person, because the natural color of the clay is a good foundation for a darker patina. In this case, however, that was not the reason, because for this portrait I planned to use a spray paint foundation that completely hides the clay color.

Sometimes my photographs do not show enough contrast between the subject and the background. Rather than call the model back to the studio for a second photographing session, I cut out the photograph of the head and mount it on a white card so that the outline is very easy to read. It is important to observe that there is as much variation among individuals within any racial group as there is among the groups as a whole. However, it is worthwhile to make some generalizations, because they will help you to be more alert to the individual differences you will find. The differences between ethnic groups are superficial compared to the characteristics shared by all human beings, but in developing a likeness you must concentrate on these subtle differences. You must always depend on your eyes and your camera, rather than on stereotypes. In general, black people and Europeans have

longer heads, while Asians are apt to have wider heads. The lower half of the black person's face protrudes relatively more than the Caucasian's face. The nose is flatter and wider; the lips are fuller and to varying degrees everted. You can see some of these characteristics somewhat attenuated in Lois's head. Her profile bears a strong resemblance to the famous portrait of Queen Nefertiti of Egypt.

This portrait of Lois offers a good example of the use of accessories to express —he subject's style. The chopsticks in her hair are part of an interesting collection of ornaments that she uses with flair and originality.

I decided to experiment with a different patina this time. Several coats of jade green spray paint cover the surface. Then I applied a mixture of wax and graphite powder and buffed lightly. The graphite did not tone down the green enough. On that account I added a coat of wax mixed with English red. This turned out to be too orange to look nice with the base, a dull bluish-red Formica. It was necessary to add cobalt blue to the English red wax until it matched the color of the base. The result is a patina that has some undertones of the base's color.

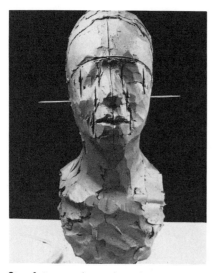

Step 1. I start in the usual way by setting up a head and marking the locations of the features, roughly filling in the connecting curves. Notice the clean crisp surfaces of the earthenware clay.

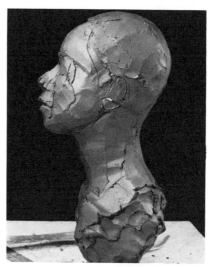

Step 2. Compare the roughly formed head to the profile photograph of Lois and notice that the general relationships of the chin, nose tip, and hairline are already established.

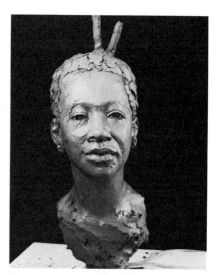

Step 3. After one-and-a-half hours of modeling, the features are all beginning to take shape. The hair style and ornaments add to the design, but the contours are not soft enough, so the face looks too old.

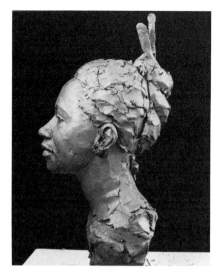

Step 4. In profile it is obvious that the cranium is not long enough and, therefore, the design is not well balanced. I correct this right away by checking the measurement chart against the clay head, using the calipers, and add clay where necessary.

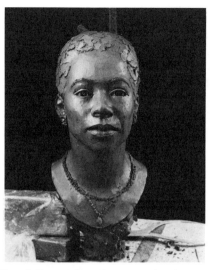

Step 5. This is as far as I can go working from photographs. You can see that the features are now carefully defined, the lower edge is designed, and the necklaces are in place.

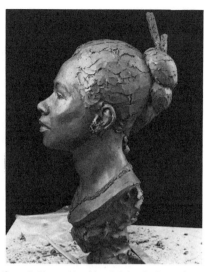

Step 6. The profile of Lois's left side shows the design of the hair and the little curls at the nape of the neck.

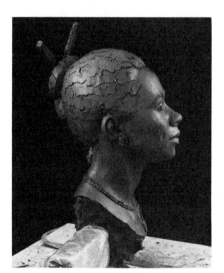

Step 7. The right profile illustrates the long head and the slightly protruded lower face with full lips just a little everted. The twist of hair at the back is in perfect balance with the face.

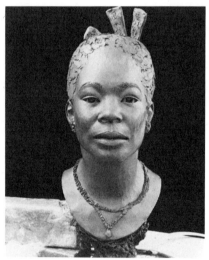

Step 8. When Lois returned to the studio she was wearing three chopsticks in her hair. I immediately incorporated the third one since it seemed to suggest a better composition.

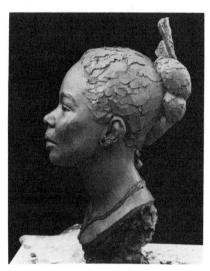

Step 9. My last effort is to model all the curves more carefully with my favorite boxwood modeling tool. I almost never form the clay with my hands, because the effect is not as crisp as when the clay is moved with a tool.

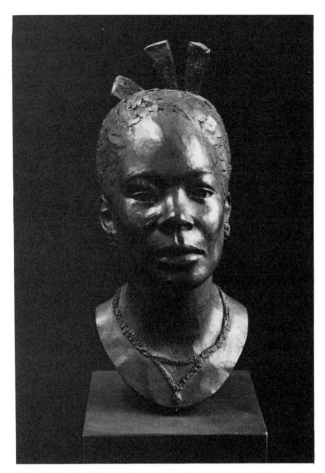

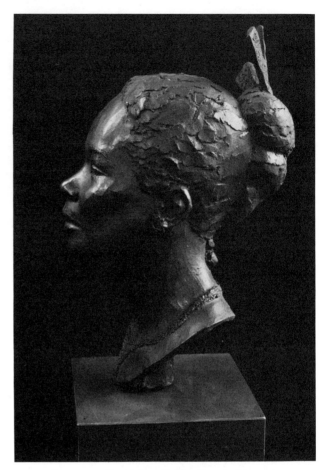

Step 10. I apply a dark bronze finish using jade green spray paint. Over that I put wax mixed with English red and cobalt blue dry pigment. Finally I mount the piece on a Formica-covered base.

Lois, earthenware, 16"h x 6½"w x 8½"d, collection of the artist.

MODELING A WOMAN WEARING GLASSES: SARAH CROOKE

Sarah is my sister-in-law. When she appeared for the photography session, I was surprised to see she was wearing glasses even though she wears them all the time. That is the heart of the problem of doing a portrait with glasses. When you are accustomed to seeing a person who wears them, you forget the glasses are there and just see the person. However, in a portrait sculpture the glasses cast a dark shadow on the face. The head is not animated, of course, so there you are with those hard, still glasses between you and the face. The result is that you see the glasses before you see the portrait as a whole. How do you solve that problem? Here I present one possibility. You may be able to develop a different way.

First, I photographed Sarah both with and without her glasses. Some of the pictures show her eyes and the others show the size, shape, and location of the frames. I selected a stoneware clay for this portrait because it is easy to work with and I needed all the help I could get with those glasses. First, I modeled her head without glasses. Sarah and I worked very hard on the likeness for the first two modeling sessions without the glasses. Sarah commented, "I keep hoping it will suddenly look like a person with a great deal of character who also looks like me."

After the face was done, I added the glasses. Using artistic license, I blended the rims right into the face so they disappeared altogether along the lower edge. In order to do this, the frames are modeled closer to the face than they should be. It has the added advantage of shortening

the ear pieces that might otherwise crack as they shrink in drying. The spaces between the ear pieces and the cheek-bones are filled in to add strength.

The final part of the strategy for minimizing the obtrusiveness of the glasses was to select a very dark patina so that the shadows cast by the frames would be somewhat less noticeable.

In this portrait I was trying to reproduce a certain expression Sarah has on her face just before she makes one of her witty remarks. In that attempt I failed, but her friends recognize the portrait even when they are not expecting to see one of her. To that extent it is successful.

In general, Caucasian heads are not as broad as Asian heads. The brow ridge is more pronounced especially in men. The nose and chin jut forward. The lips are generally thinner and the eyes more deeply set. For each of these features the range of differences is enormous. You can see all of these characteristics in Sarah's portrait.

The contours of a woman's face in all races are softer than those of a man. Each of the features is apt to be more delicately formed. The face is usually smaller than that of the male and the eyes proportionately larger. These sexual differences are often emphasized by a woman's coiffure, plucked eyebrows, and cosmetics. To some extent, as an artist you can exaggerate these characteristics in a portrait to increase the overall impression of feminity or masculinity. For a more detailed discussion of these sexual differences, please refer to John Liggett's excellent book, *The Human Face*, listed in the bibliography.

This front view of Sarah with glasses is fairly clear, although a good view of her eyes is slightly obstructed by the glare on her glasses.

This picture gives a better view of the eyes and also the brows and cheeks.

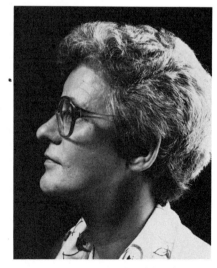

This photo of Sarah's left side with her glasses on shows the relationship of the frames to the side of her face, and particularly how they rest on the nose, cheekbone, and ear.

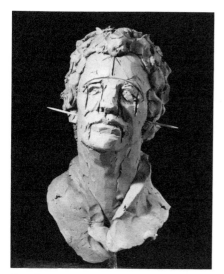

Step 1. I start the head in the usual manner and add two slabs of clay for the neckline of the dress.

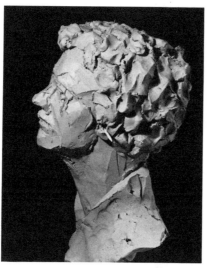

Step 2. In this profile you see the volumes of face, hair, and neck roughly established as well as the tilted attitude of the head.

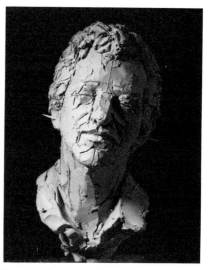

Step 3. In this front view the features are marked as well as the tilt of the head. The modeling of the neck has been started and the collar is more clearly defined.

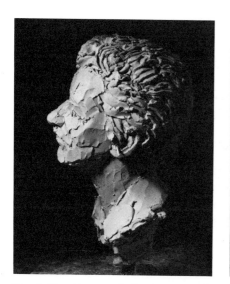

Step 4. Here I have roughed in the pattern of hair growth and started modeling all of the features. As you can see, I'm working each area to the same degree of finish before I move on.

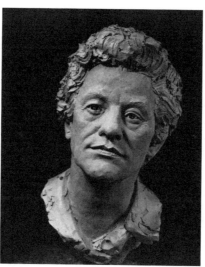

Step 5. This full face without glasses shows the patterns of facial muscles, which are more developed than in an adolescent face.

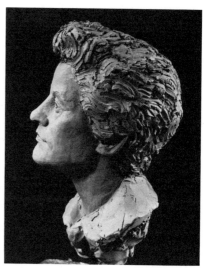

Step 6. Here you can see the side of the head nearly complete without glasses. The hairline is still too abrupt, so I make note that this must be blended into the face a bit more.

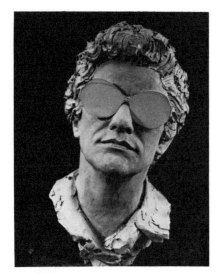

Step 7. To model the glasses, I begin by cutting out a paper pattern and fitting it on the face.

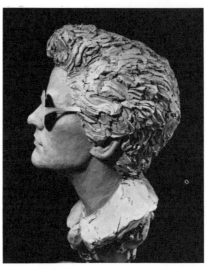

Step 8. From the side you can see how the paper frames meet the hair.

Step 9. Next, I cut the centers out of the paper glass frames and cut some strands of Fiberglas to fit the frames and act as reinforcement for the clay.

Step 10. I cover the paper frames with strips of clay into which I embed the strands of Fiberglas, and then trim the flattened clay to the shape of the paper frames.

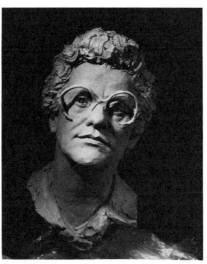

Step 11. Here you can see how I set the clay frames on the face, peel away the paper, and cut off part of the lower edge of the frames. This requires a lot of patience.

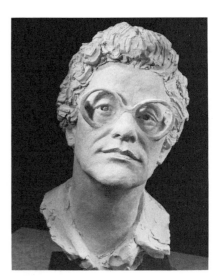

Step 12. To make the frames less noticeable I blend them right into the face, and model the rims flat trying to make them symmetrical.

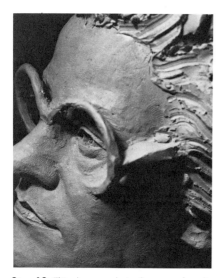

Step 13. This close-up photo shows you how I thickened the ear pieces in order to attach them to the face for extra strength.

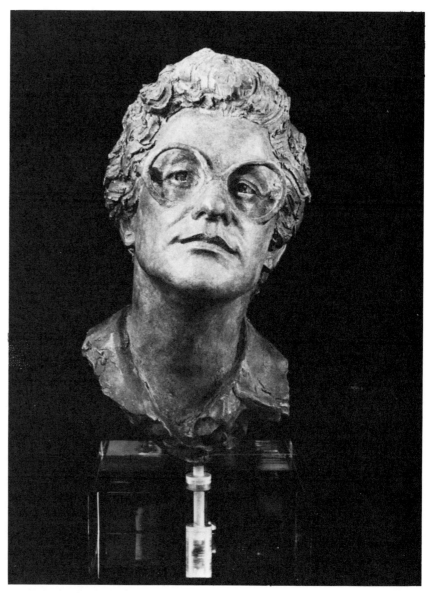

Step 14. This is the finished sculpture mounted on a Plexiglas base. The patina is composed of shellac and alcohol mixed with a heavy dose of mars violet and viridian to get a good dark foundation. On top of this are several coats of wax with ochre, burnt umber, and green earth pigments.

Sarah, stoneware, 15"h x 8"w x 9"d, collection of Mr. and Mrs. Charles Eric Crooke.

DEMONSTRATION 6

MODELING A MATURE MAN: BILL PARSONS

If I have a favorite sort of person to portray, it is a mature man with an interesting face like Bill Parsons'. He is a gardener, swimmer, tennis player—a man of so many interests that we never even had time to get to the subject of his profession. He was a little difficult to photograph though, because he is so animated. I had to move quickly with the camera to catch him holding still. I was very lucky to catch on film the very expression and attitude of the head that I wanted to use in his portrait.

You will notice again in this series of pictures that the work at every stage of development expresses something of the statement I want to make about the subject. Also note that his face is asymmetrical in a fascinating way.

I love to leave a rough surface texture when modeling clay even when the head is that of a baby. Sometimes I make the hair and clothing extremely rough so that the moderately rough face will seem smooth by contrast. All of the portraits so far in this chapter have been modeled very smoothly. The one of Richard in chapter 2 is moderately rough, but this one of Bill Parsons has the texture I like best. The roughness catches the light and sparkles with vitality.

In this portrait I applied the hair roughly in large slabs of clay, but the surfaces of these slabs are smooth to reflect

light and give the impression of light-colored or white hair. If Bill's hair were black, I would have given it a deeply incised texture to create dense shadows and a darker effect. His skin is tan from spending so much time outdoors. It contrasts nicely with the smooth shirt collar. The deep undercuts around the tie provide contrasting shadows and the incised lines of the coat collar seams direct attention upward toward the face. These are similar in range of tonal value to the contours and lines of his face. The muscles of his face are well developed and easily identified in contrast to those of Josh and Aric, whose facial muscles blend softly together under smooth contours.

When most people smile, the corners of the mouth rise. When Bill smiles the corners of his mouth go down, and yet the effect is definitely one of amusement. His eyes crinkle up, the muscles in his cheeks contract, dimples appear, and one eyebrow rises pushing the flesh of the forehead up as it goes. Bill's face carries the evidence of many smiles. Some of his photos have a serene and thoughtful look. I can't imagine him with an unpleasant expression.

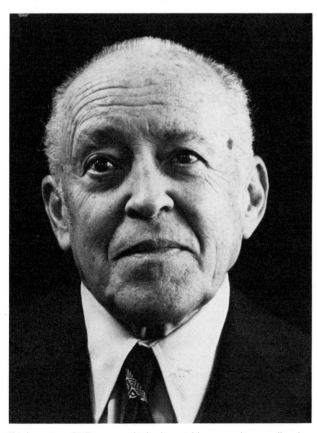

This front view of Bill expresses his lively sociable personality as well as the characteristic way he carries his head.

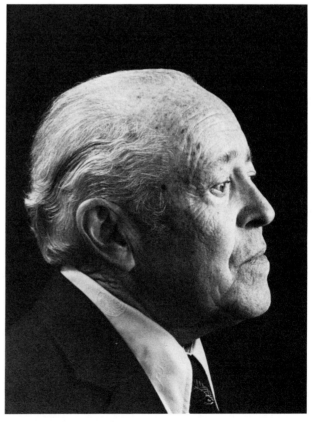

The right profile shown here matches the tilt of the head in the full face photograph, but does not show the curve of the brow and the nose very well.

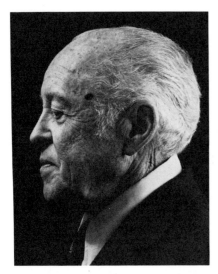

The left profile shows the curves I need to see, although the expression is more contemplative than the one I want to use.

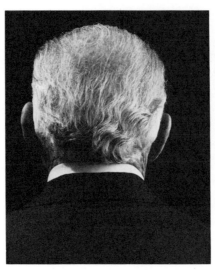

The back view indicates the pattern of hair growth and the general shape of the head.

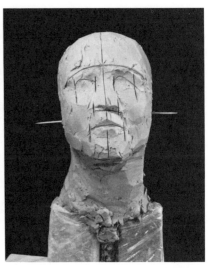

Step 1. Following the usual procedure for establishing the basic shape, I set up the head in the chosen pose according to Bill's measurements.

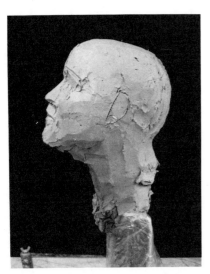

Step 2. You can see here that the chin is up a little too high. A firm pull with the head between the palms of the hands is all it takes at this soft stage to modify the pose somewhat.

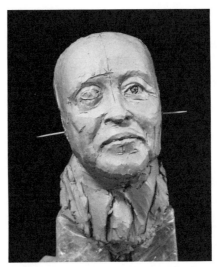

Step 3. I model the facial features roughly and then begin to refine them.

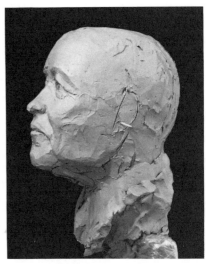

Step 4. I check the sides to see that the face isn't being modeled too flat.

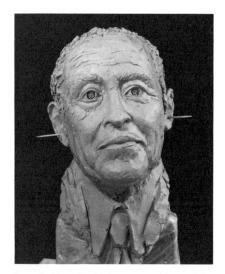

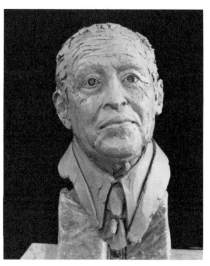

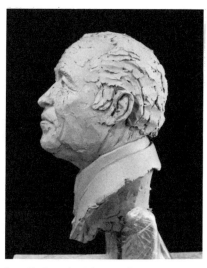

Step 5. Next, I add the ears and hair while continuing to work over the entire surface, clarifying the forms still further.

Step 6. I add a coat collar to suggest a formal business portrait to balance the mass of the head, and to indicate Bill's general physique. Then I continue to elaborate and refine every aspect of the portrait.

Step 7. From the side view the expression is developing well, but the eyes are looking upward a bit too much.

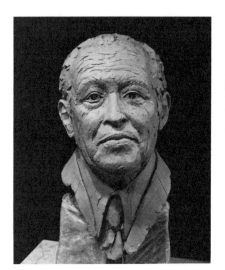

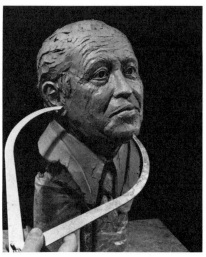

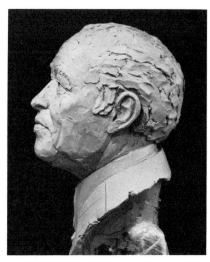

Step 8. I correct the eyelids so the glance is more nearly level and add a simple pattern to the tie and coat collar.

Step 9. This is as far as I can go working just from the photographs. I check the measurements again to be sure that none of them is very far off. So far I'm on the right track.

Step 10. The work has gone so well just from the photographs that I have to make only a slight correction to one eyelid, modifying the transition from the eyelid to the brow, during the modeling session with the sitter present.

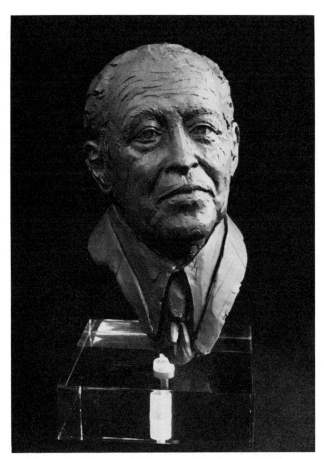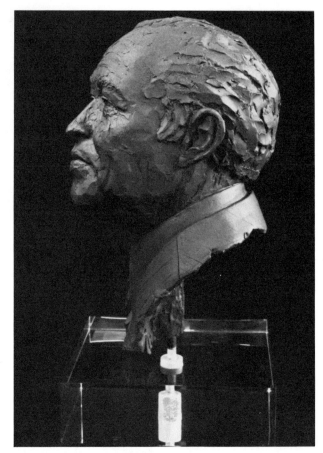

Step 11. There was only one modeling session from life and that only lasted a few minutes. The sculpture has a bronze finish of medium tone similar to the one used on Richard's portrait (described in the next chapter). Here you see the portrait mounted on a Plexiglas base.

Step 12. The finished portrait of Bill.

Bill, stoneware, 15"h x 7"w x 8"d, collection of the artist.

CHAPTER 6

FINISHING THE PORTRAIT

Once your portrait sculpture is fully modeled and you are satisfied with the likeness, there are several steps you must follow before you can deliver the finished piece to your client. In this chapter, I will explain all of the steps involved, including hollowing out the head, drying, firing, applying a patina, and mounting the work.

PREPARATIONS FOR MOUNTING

Once the modeling is complete and before you hollow out the head, it is important to mark the midpoint of the lower edge of all sides of the head—front, back, and each side. Make small marks with the edge or point of a tool. This will help you locate the center of the piece when you are ready to install the mounting rod later on. It also provides a vertical line after the armature is removed. If you forget to do this you will be surprised at how difficult it is to remember just how far forward or to either side the head was tilted.

To determine where the center line should be, I begin by standing a block of wood on end in front of and behind the sculpture, and then measure with a ruler, as you can see in step 1. I mark this center line with the edge of my modeling tool. It seems appropriate for the nose to be a little bit in front of the edge of the base. That seems to add a little forward movement to the sculpture. The principal mass still appears centered and stable. Next, I set the blocks on either side of the head, looking at it from the front (step 2), and measure again for the center line. Since Richard's head is tipped, the edge of the neck is not centered, but the mass as a whole is. In step 3 you can see that I mark the second side in exactly the same way.

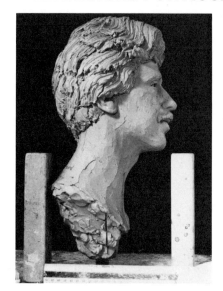

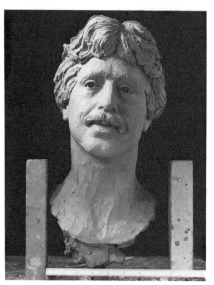

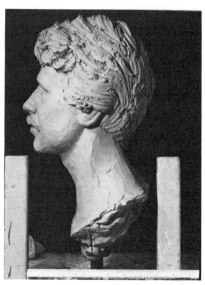

Step 1. I set up two blocks of wood to mark the appropriate location for the edges of the base, measure the center point of the distance between them, and mark the clay where the supporting rod will be located.

Step 2. I move the blocks to the sides and measure to find the center of the sculpture from the front and again mark the clay.

Step 3. I move the blocks again and mark the center of the other side.

PRELIMINARY DRYING

Before you can fire the clay, it must be completely dry and the armature must be removed. If you try to let it dry on the armature, the clay will shrink but the iron armature will not. As a result, the clay will crack. In addition, the sculpture must be completely hollowed out until it is a shell about ½″ thick or less. This is necessary so that the clay dries within a reasonable length of time and does so consistently throughout without warping or cracking.

If you were to try to hollow out the piece as soon as you finished the modeling, it would be pushed out of shape in handling. You must allow it to dry enough to remain stiff while you dig out the inside clay. It should be stiff enough so that you don't make fingerprints or dents on the surface, but still be soft enough to cut apart with a wire. You will learn by experience how to judge this. If you try to cut it too soon, you can easily put it back together again. If you wait to cut it open until it is too dry to cut with a wire, you will have to try using a stiff knife. Then it will surely be a mess, and you may lose the work altogether. So it is best to try cutting part way through to test the stiffness before it becomes too dry to cut. The time required for drying to this extent varies with the humidity of the studio and the moisture content of the clay. If you were working in the dry winter air of a heated house and used fairly stiff clay for modeling, it might be only a half day before you would be able to slice the head very carefully and begin hollowing. However, if you had started with soft, fairly wet clay in

humid summer weather, then it might be a week before you could handle the work without distorting it.

HOLLOWING OUT THE HEAD

The easiest way to hollow out the head is to begin by slicing off the back of the head from top to bottom. You don't want to slice half way down and get your wire stuck on the armature, so it is a good idea to hold your wire vertically beside the portrait and look underneath to see where the pipe rises inside the clay. See step 4. If you cut with the wire behind that pipe, it will not catch any part of the armature because all of the other pieces of pipe are in front of it inside the head.

You will notice in the same photograph that the section at the nape of the neck is going to be very thin. So when slicing off the back of Richard's head, I pull down on the handles of the wire, as in step 5, until I get to the bottom of the hair and then I pull toward myself. This results in cutting off just the back of the hair. Then I make a second cut to remove the back of the neck and shoulders. Now I have the two back pieces lying on the armature base and the main bulk of the portrait still safely held up by the armature.

Before digging out the clay from the center of the head, I make sure I have a plastic bag handy to hold the scraps and an atomizer to spray the clay. The clay, which will be reused, should not dry out any more than necessary. By keeping it in good condition, it's a lot easier to reuse than it would be if it had dried out and had to be restored. As I work, I keep putting these scraps in the plastic bag where it is easy to spray them.

I start hollowing out by cutting a strip of clay inside the edges of the sculpture to mark the thickness of the shell as shown in step 8.

I continue to hollow out the top of the head, checking the thickness of the shell as I go along by feeling with my thumb on the inside and fingers on the outside. When the hole is deeper than the length of my thumb, I gauge the thickness of the shell by holding one hand lightly on the outside and the other on the inside. By doing this you can get a pretty good feel for the thickness. Absolute accuracy is not necessary.

When the top of the armature is uncovered, I remove the first pipe as you can see in step 10. If the face has been modeled far enough in front of the pipes, you can sometimes remove one or two more pipe sections, but this is not necessary. Before hollowing out the neck, I mark a vertical center line using a drafting triangle, also shown in step 10.

HOLLOWING OUT THE HEAD

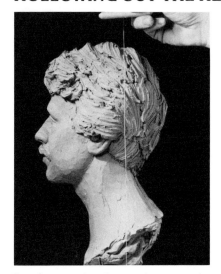

Step 4. Notice where the vertical pipe enters the bottom of the sculpture. I am holding the wire so that it will slice away the head behind this pipe.

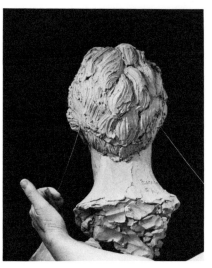

Step 5. Here I am cutting away the back of the head by pulling the wire by its handles slowly down through the clay. Notice the title, copyright mark, signature, and date incised in the clay on the lower right side of the neck.

Step 6. The back section was so thin at the nape of the neck that I had to slice it off in two sections to avoid having it break while being handled.

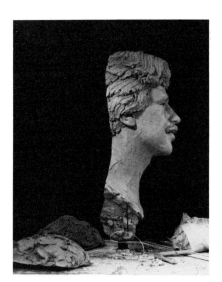

Step 7. Here you see how the piece looks from the side with the back cut away. The cut is not perfectly straight, but that makes it easier to match up again when the pieces are reassembled.

Step 8. I have started to dig out the clay with the ribbon tool you see here by scooping out a strip that indicates how thick the finished piece will be. I put the scrap in the plastic bag and spray it with water.

Step 9. I hollow out the cranium as far as I can go with the armature still in place. You can see the top section of pipe and the first elbow.

Step 10. I remove the top section of pipe and dig out more clay in the area behind it. Using a drafting triangle, I mark a vertical line down the center to help in placing the mounting rod later.

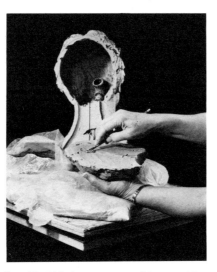

Step 11. While the main section of the portrait is still safely held on the armature, I hollow out the back sections, cradling them in the hollow of my hand to make sure they retain their shape.

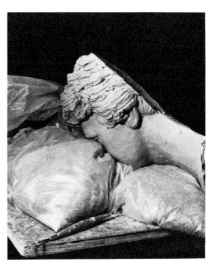

Step 12. I unscrew the armature from the floor collar and gently place the face between sandbags to cushion it while I hollow out the neck.

Step 13. I hollow out the neck enough to free the armature, being careful to preserve the vertical line that I drew with the triangle.

Step 14. I gently remove the armature by wiggling it slowly until it comes loose. You can still see the pattern in the clay where the armature was embedded.

Step 15. I finish hollowing out one side of the neck and face behind where the armature had been. Then I mark the vertical line along the center so that it will not be lost when I hollow out the other side of the neck.

Next I hollow out the two back sections of the head, pulling the ribbon tool toward me and lifting the clay out rather than pushing down to dig out. This minimizes stress on the shape of the section. I hold the piece in my cupped hand, which also helps retain the shape. When these two pieces have been hollowed out to the desired thickness, I set them in a safe place away from the scene of action and any possible accidents.

Next, I set out several small sandbags to make a cushion for the face. You could use folded rags instead. Then I unscrew the bottom pipe of the armature from the floor collar and gently set the face in a depression formed by the sandbags. See step 12.

Now, I cut away the clay to one side of the vertical line until the armature is completely uncovered (step 13). With a little careful tugging the armature breaks free of the clay leaving the rough imprint visible.

With the armature out of the way, it's possible to hollow out the rest of the piece. I hollow out one side of the neck first, keeping the vertical line until I can match it with one drawn on the inside of the shell (step 15). Next, I hollow out the rest of the shell and build a little wall of clay on either side of the vertical line to receive the mounting rod. The channel made by these two little walls must be partly filled with clay at the bottom edge and tapered toward the top of the channel, so that when I install the rod and lift the head up the face will tilt forward or back at the proper angle.

Since the clay at the bottom end of the channel must be thick, I pierce it at frequent intervals with a cake tester (step 16). These punctures do not go all the way through the clay; they just allow moisture to escape during the drying and firing stages.

I use this same system of puncturing for any section of the portrait which is especially thick and difficult to hollow out, such as the nose or a lock of hair.

REASSEMBLING THE HEAD

The pieces of the portrait must be put back together tightly so that the seam does not reopen during drying or firing. To be sure that the bond will be secure, I score the edges of the pieces with a palette knife and then moisten them with a wet brush (step 17). The scored cuts soak up the water from the brush and make the edges a little muddy. These muddy surfaces bond very well when put together, but you can see the seam. The sculpture is still soft enough so that I can remodel the seam with my modeling tool. When that has been done you can't see where the cut was made.

DRYING AND FIRING

The sculpture must dry completely before it can be fired. If there is any moisture present when the clay goes into the kiln, the sculpture is likely to explode. This is because, as the kiln heats up, the moisture in the clay turns to steam. It's the expansion of the steam that causes the explosion. If the clay is thoroughly dry, you need not worry about it exploding.

It's best to allow the work to dry slowly and evenly. If I have plenty of time, I uncover the sculpture during the day to dry and then cover it with plastic at night, allowing the remaining moisture to equalize throughout the piece. Using this method, the nose and ears do not dry faster than the rest of the piece. The actual drying time depends on the temperature and humidity in the studio. In winter when the house is heated, the clay dries faster than it does on a humid summer day. Generally, I allow about three weeks.

The evening before I fire, if there is any doubt about the dryness of the work, I usually put it into my kitchen oven set below 200°F for the night. By morning it is thoroughly dry and I feel confident about firing it.

I used to have my firing done at a local ceramics studio. For a small fee, my work would be fired along with other work made by the studio's students. For a couple of years, a friend fired my pieces along with her pots. Now, I have a small electric kiln in the utility room of our house. At about eight o'clock in the morning, I generally turn the kiln on low with the lid propped slightly open and the plugs out. At nine I close the lid and at ten I turn the heat up one notch. At eleven o'clock I insert the plugs in the peep holes. I turn the heat up at increasingly frequent intervals until it is on high at about half past two in the afternoon. I leave it on high for an hour and then turn the kiln off and unplug it. This seems to bring the temperature up to about cone 3 or 2185°F. Then I let the kiln cool until the next morning before opening it. This is the procedure I use for stoneware and porcelain. They fire to rather hard bisque, but not too hard for the finish to adhere. With earthenware I do not fire the kiln for as long a time—about five hours instead of six-and-a-half. There is an automatic kiln sitter that can be set to cut off the current before the kiln gets too hot.

During drying and firing the clay shrinks a total of ten to fifteen percent. If you model a piece twenty inches high and ten inches wide it will shrink to about seventeen or eighteen inches high and eight-and-a-half or nine inches wide when fired.

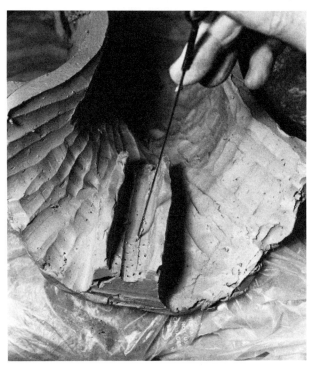

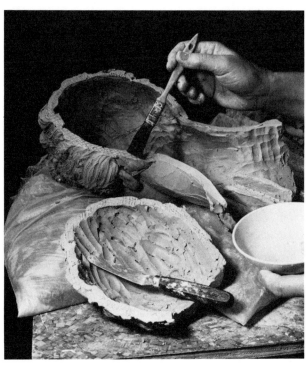

Step 16. After hollowing out the rest of the neck and face I build a wall of clay along each side of the center line to house the supporting rod. The channel is thick at the bottom so that the rod will be vertical. I puncture holes in the thick part with a cake tester so the steam can escape during firing.

Step 17. You can see that the edges where the pieces will fit together have been scored with the palette knife. I moisten the scored edges with a wet brush so they will stick together.

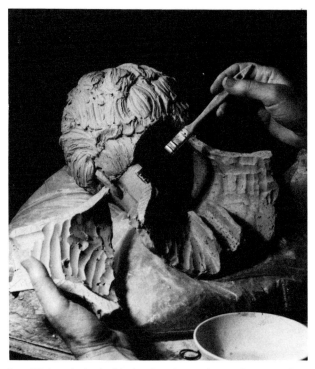

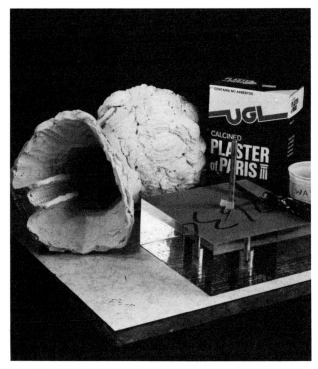

Step 18. I put the back of the head in place and repair the seam with a modeling tool. Then I score, moisten, and reassemble the last piece. Now the sculpture must dry completely before it can be fired.

Step 19. I set the length of threaded rod in the hole in the base and mark the point of entry with tape. Through the Plexiglas you can see that the end of the rod is resting on a nut. This is so that the rod as installed will not be long enough to protrude from the bottom of the base and scratch the table.

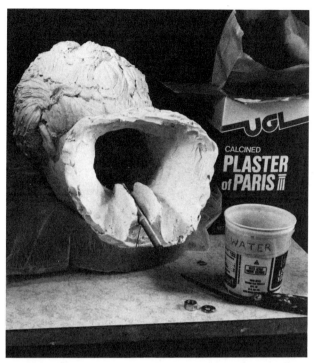

Step 20. I put the rod in the channel to the place where the tape is wrapped around the rod. I mix plaster and water to the consistency of thick sour cream and fill the channel around the rod until the plaster is level with the top of the clay walls.

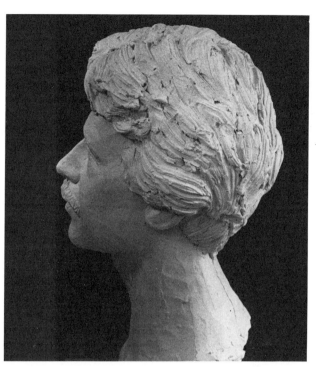

Step 21. When the plaster has hardened I slide the rod into the hole in the base and find that I have installed the rod too far forward. The sculpture hangs out too far over the back of the base. I have to dig the plaster out with a sharp awl and free the rod so it can be reset.

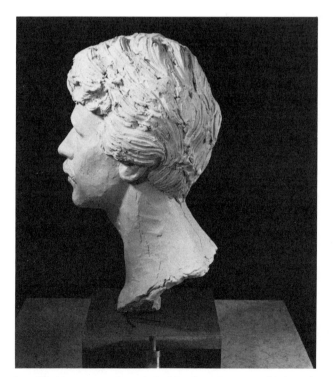

Step 22. After resetting the rod I find that the sculpture is well balanced. You can see that the protective paper has not yet been peeled off of the Plexiglas top or bottom.

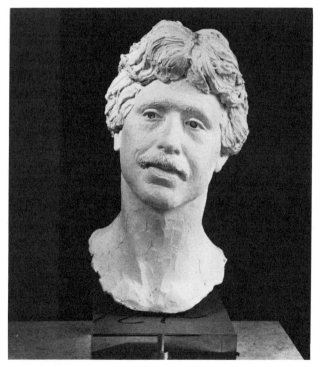

Step 23. From the front the mass is well balanced over the base. The face is tilted just enough to suggest movement. Now the plaster must dry completely before the patina can be applied. Otherwise the moisture of the plaster will creep through and the finish will flake off.

CHOOSING A BASE

For the past several years I have been using Plexiglas bases cut and polished to order. The manufacturer drills a $\frac{5}{16}''$ hole through the center to receive the $\frac{1}{4}''$ threaded rod, which I fasten onto the sculpture. The $\frac{5}{16}''$ hole is countersunk at the bottom $\frac{3}{4}''$ deep with a bore $\frac{3}{4}''$ in diameter (large enough to receive the nut and the socket wrench with which I tighten it). Such a base is shown in step 23.

A less expensive but handsome base can be made of plywood or particle board covered with a plastic laminate, like the ones used on kitchen counters. Plain flat black is a good choice, because it does not distract from the portrait itself. Some of the patterns that look like wood are nice and might be selected to go with the client's furniture. I used to buy these bases made to order from a shop which makes custom kitchen counters. They did not drill the holes for me, but that's not hard to do especially if the base has no bottom. The nut, lock washer, and end of the pipe would all be out of sight inside the box.

Stone is another possible choice for a base, but it is usually very expensive to have cut, polished, and drilled.

INSTALLING THE MOUNTING ROD

You can't just glue the sculpture onto the base. The joint would not be strong enough. Therefore, you must install a threaded rod that will run through the channel inside the neck and down through the base. I use a $\frac{1}{4}''$ threaded rod, a standard item in any hardware store. I set it in with plaster of paris, which conforms to the shape of the channel and flows into the threads of the rod holding it very securely.

As you can see in step 19 I set a length of threaded rod in the base and mark it with a bit of masking tape to determine the length that must protrude from the bottom of the sculpture. I allow a little less than the thickness of the base so that there will be no chance of the rod extending slightly through the bottom of the base and scratching the surface on which the work is placed.

Next, I mix up a batch of plaster of paris and water that is about the consistency of sour cream and spread a thin layer in the channel of the fired head. I set the rod in the wet plaster and lightly pack plaster in the channel until it is even with the top of the clay walls. (step 2.). I try to line the rod up with the marks on the neck edge so that it will be centered and vertical. Even with these marks as a guide, I don't always judge correctly and sometimes the sculpture is not centered over the base. Then I have to dig the plaster out with the point of an awl and try again. Sometimes I

have to plaster the rod in place three or four times before it's correct. The proper installation is demonstrated in steps 22 and 23.

SELECTING A PATINA

There are many kinds of finish you can apply to the fired clay to protect and color the surface. I will describe a few of these and demonstrate in the photographs the most complicated one.

A very simple finish is made by mixing half a cup of table cream with a small pinch of powdered yellow ochre and a few grains of burnt sienna. These must be stirred together until the dry pigments are thoroughly dispersed in the cream. Then you rub this all over the sculpture and buff it dry. The fat in the cream seals the surface and the pigment gives it a faint ivory color.

An alternative is to spray the portrait with matte finish paint. If you alternate several colors of paint you can develop a finish that resembles sandstone or granite. Try examining pieces of rock to determine what colors you might use. For example, it might be a combination of white, gray, and black or cream, tan, and rust. When the painting is done give the portrait a thin coat of paste wax and buff it lightly.

Another possibility is to spray it with red rust inhibitor paint and then coat with a mixture of wax and graphite powder. When polished this makes a very impressive finish—a dark rich metallic effect.

The patina I have selected for Richard's portrait is intended to imitate bronze. First, I mix about $\frac{1}{3}$ cup (2.7 oz.) of shellac with an equal amount of alcohol, and then stir in about $\frac{1}{4}$ teaspoonful of mars violet dry pigment and an equal amount of viridian. After stirring this thoroughly, I brush it over the outside of the portrait and the inside part of the neck that will show when the piece is mounted. The color precipitates into the crevices in the piece and brings out the form (see step 25). This shellac mixture dries in about fifteen minutes.

Next, I add about $\frac{1}{4}$ teaspoonful of a mixture of viridian and white powdered pigment to a few tablespoons of paste wax on a piece of wax paper. I blend these together thoroughly with a palette knife so that the lumps of wax are all broken up and the color is evenly distributed. I dip the bristles of a sash brush in this mixture and then tamp the brush on the wax paper until the brush is nearly dry. Then I stipple the color very lightly onto the portrait continuing with a nearly dry brush until the whole piece has a light powdering of color. Using a clean brush, and fresh wax

mixed with a few grains of English red, I stipple over the entire surface again. With a third clean brush, more wax, and green earth, I add yet another layer. These first few coats are allowed to dry for several hours. Then I buff the piece lightly with a soft cloth, and add a layer of wax with yellow ochre in it, followed by a coat of wax with burnt sienna. Each time I use a clean brush. By this method I build up layers of color that show through each other, because they are only stippled on lightly. This gives an impression of depth and when buffed has the gloss of metal.

APPLYING THE PATINA

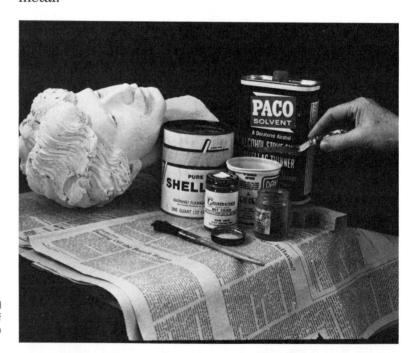

Step 24. Here I am mixing ⅓ cup (2.7 oz) of shellac and ⅓ cup (2.7 oz) of alcohol with about ¼ teaspoonful of mars violet dry pigment and an equal amount of viridian for the sealer coat.

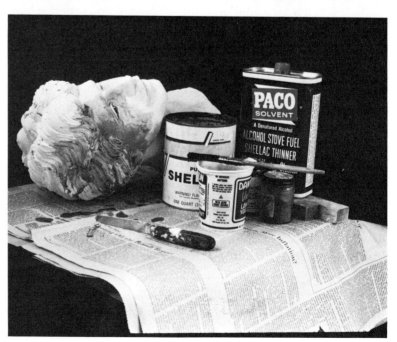

Step 25. You can see where I have started painting the sealer on the portrait. Already the color helps to bring out the form by precipitating into the crevices.

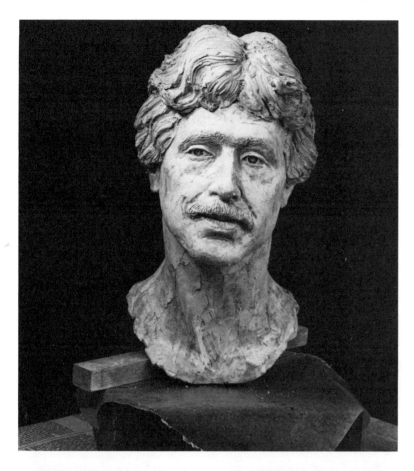

Step 26. The sealer coat is finished and you can see the hairs of the moustache, the curls, and the eyebrows more easily than when the piece was completely white.

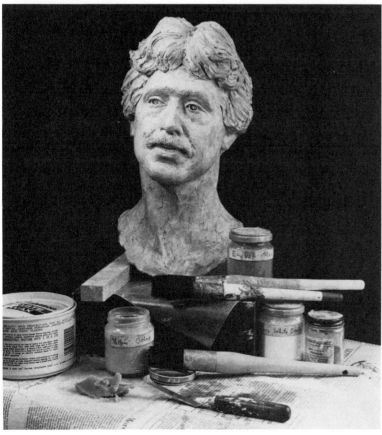

Step 27. Here you see a pile of wax on a piece of wax paper. Using a small amount of yellow ochre pigment mixed with the wax, I stipple over the entire portrait with a sash brush. The other two brushes have been used for coats of viridian and white, and English red.

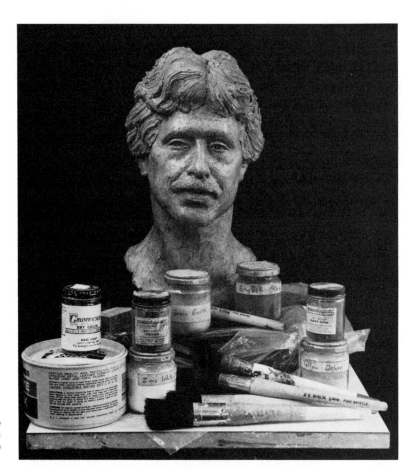

Step 28. A total of five coats of wax and successive layers of green earth, yellow ochre, and burnt sienna have been applied. The piece has a slight sheen, the result of buffing the wax.

Step 29. Here is a special polish, called Brillianize, for cleaning the Plexiglas base and a special cloth. An ammonia cleaner would dull the Plexiglas. The lock washer and nut are for securing the head in position so that it does not spin when attached to the base.

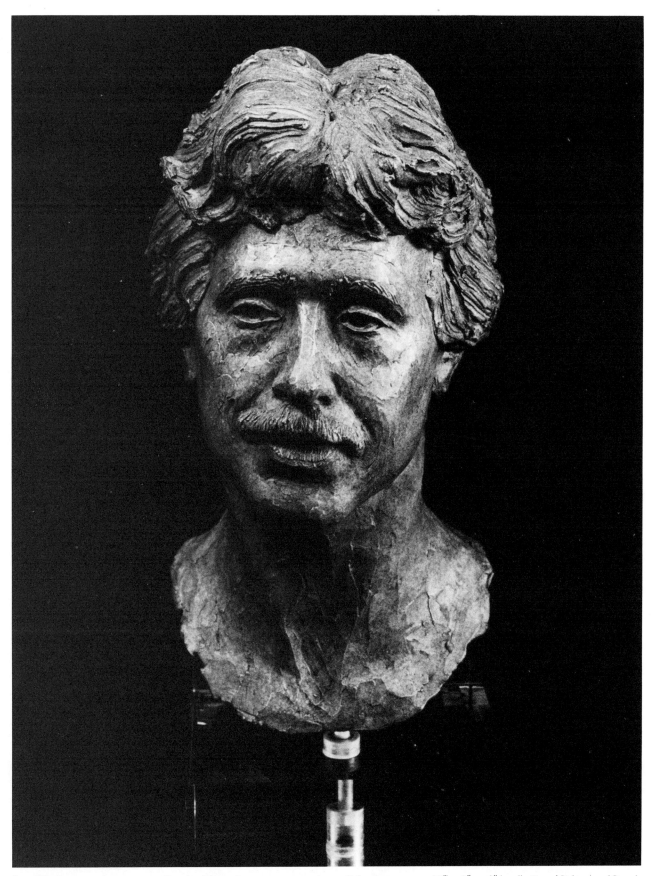

Step 30. The mounted portrait is ready to be delivered.

Richard, stoneware, 16"h x 8"w x 8"d, collection of Richard and Pamela Halstrick.

MOUNTING THE PORTRAIT

For Richard's portrait I have chosen Plexiglas for the base because I enjoy the impression of lightness and the floating quality the clear base gives. There should be a little space between the sculpture and the base so that it will not be scratched if the sculpture turns. I put a finishing washer round side down on the threaded rod and push it up against the sculpture before inserting the rod in the hole in the base. This makes the sculpture float about $\frac{1}{8}''$ above the base. Then I slip a lock washer into the countersunk hole in the bottom of the base and tighten a nut in place with a socket wrench. The nut must be snug enough so that the sculpture doesn't turn around, but not so tight that it pulls the rod out of its plaster bed.

Now the portrait of Richard is finished.

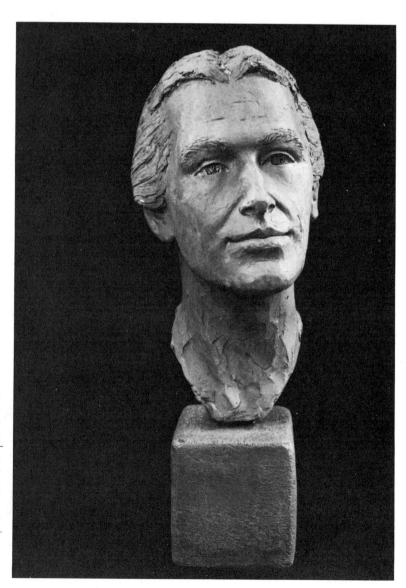

Charles, stoneware, 17"h x 7"w x7"d, 1980, collection of Charles Halstrick. The clean-cut features speak for themselves. The hair is simply styled, revealing the shape of the head. I like the edge that follows from the pit of the neck up around a graceful curve over the shoulder, leading the eye behind and down again on the other side. The base is a hollow block of clay with a hole in the top for the supporting rod. It was fired separately and given a darker color with a stronger concentration of the same pigments used for the head. After the base was fired, I turned it upside down and set a hollow metal tube over the hole. The tube was ¾" shorter than the inside of the base. I poured plaster around the tube to fill the block to ¾" from its lip. This made a solid block with a passage down the middle for the threaded rod and space at the bottom for lock washer and nut.

SELECTED READING

Goldscheider, Ludwig. *Michelangelo*. 4th ed. Greenwich, Conn.: New York Graphic Society Publishers, Ltd., 1962.

Goldscheider, Ludwig; Schneider-Lengyel, Ilse; and Story, Sommerville. *Rodin Sculptures*. Great Britain; Phaidon Press, 1964.

Horizon Magazine, the Editors of. *The Horizon Book of Lost Worlds*. New York: American Heritage Publishing Co., 1962.

Liggett, John. *The Human Face*. New York: Stein and Day Publishers, 1974.

Lucchesi, Bruno. *Modeling the Head in Clay*. New York: Watson-Guptill Publications, 1979.

Peck, Stephen Rogers. *Atlas of Human Anatomy for the Artist*. New York: Oxford University Press, 1951.

Sheppard, Joseph. *Anatomy: A Complete Guide for Artists*. New York: Watson-Guptill Publications, 1975.

LIST OF SUPPLIERS

This index of suppliers of clays, tools, and kilns includes at least one in each of the United States and several in Canada and Great Britain. However there are hundreds more that you will find listed in your telephone directory under the heading Ceramics—Equipment and Supplies, Retail or a similar title.

Alabama
Alabama Art Supply, 1006 23rd St., Birmingham 35218

Alaska
Alaska Mud Puddle, 9034 Hartzell Rd., Anchorage 99507
Great Earth Studio, 5.2 Mi. Badger Rd. North Pole, Fairbanks 99705

Arizona
The Franklin Gallery, 105 N. Brewer, Flagstaff 86001

California
Bailey Ceramics, 928 El Camino Real, San Francisco 94121
Ceramic Supply of San Diego, 4100 Poplar Dr., San Diego 92105
Klay Kitchen, 12466 Washington Bl., Culver City 90230

Colorado
Van Howe Ceramic Supply Co., 11975 E 40 Ave., Denver 80216

Connecticut
Clay Art Center, 40 Beech Pt., Chester 06412

Delaware
Creative Ceramics and Supplies, Inc., 4311 Kirkwood Hwy., Wilmington 19808

District of Columbia
Jay R's Gift and Craft Shop, 1350 U St. N.W., Washington, D.C. 20009

Florida
Debra's Ceramic Nook, 7128 Conant Ave., Jacksonville 32210
Miami Clay Co., 18954 N.E. 4th Ct., N. Miami 33162

Hawaii
Keauhou Stoneware, Honalo, Maui County
Terra Ceramics, Inc., 3035c Koapaka St., Oahu

Idaho
The Potters Center, 210 W. Myrtle, Boise 83706

Illinois
Ceramic Creations, 4115 W. Lawrence Ave., Chicago 60630

Indiana

American Art Clay Co., Inc., 4717 W. 16th, Indianapolis 46222

Iowa

Le Soeurs Ceramic Supply, 2310 Hubbell, Des Moines 50317

Kansas

Evans Ceramic Supply, 1518 S. Washington, Wichita 67211

Kentucky

Polly's Playhouse, 9806 Taylorsville Rd., Louisville 40299

Louisiana

L & S Ceramic Supply, 9545 Chef Menteurs Hwy, New Orleans 70127

Maine

Me-N-Jo Ceramics, Rt. 1, Dunstan Corner, Scarborough 04074

Maryland

Eagle Ceramics, 12266 Wilkins Ave., Rockville 20852

Michigan

Milart Ceramics, 26405 Plymouth Rd., (Between Beech Daly & Inkster) Detroit 48204

Mississippi

Ceramic Village, 131 Richardson Dr., Jackson 39209

Missouri

Good Earth Clays, Inc., 501 Atlantic Ave., Kansas City 64116

Montana

Pot Pourri Ceramics, 902 Miles Ave., Billings 59102

Nebraska

Clayground Ceramics, 10544 Bondesson Circle, Omaha 68122

Nevada

Ceramic Arts, Inc., 1906 Western St., Las Vegas 89102

New Hampshire

Dora's Ceramics Studio, 87 Broadway Ave., Manchester 03104

New Jersey

Hoover's Ceramics, 501 Old Post Rd., Edison 08817

New York

Sculpture Associates Ltd., 114 E. 25th St., New York 10010

Sculpture House, 38 E. 30th St., New York 10016

North Carolina
Cary Ceramic Supply, Inc., Old Highway 64, Raleigh 27511

North Dakota
Souixland Ceramic Supply, 410 E. Main St., Mandan 58554

Ohio
Creative Little Arts Workshop, 10313 Lorain Ave, Cleveland 44111

Oklahoma
The House of Clay, 1100 N.W. 30 St., Oklahoma City 73118

Oregon
The Forming Co., 1400 N.W. Kearney, Portland 97209

Pennsylvania
Glori-Bee's Ceramic Studio, 6812 Torresdale Ave., Philadelphia 19135

Rhode Island
Cesare Ceramic Studio, 373-375 Longmeadow Ave., Warwick 02889

South Dakota
The House of Ceramics, 3035 Broad River Rd., Columbia 57433

Tennessee
Haney Ceramic Supply, 1329 Madison Ave., Memphis 38104

Texas
Upsy-Daisy, 417 N. Star Rd, Garland 75040

Utah
A.B. Ceramics, 2938 W. 500 S, Salt Lake City 84115

Vermont
Vermont Ceramic Supply, 451 W. St., Rutland 05701

Virginia
Bay Ceramics, 3101 E. Ocean View Ave., Norfolk 23518

Washington
Claymates Ceramics, 10778 Myers Way S., Seattle 98168

West Virginia
Barb's Ceramics, Dallas Pike, Wheeling 26003

Wyoming
Ceramics and Supplies, 146 S. Elk, Casper 82601

CANADA

Mercedes Ceramic Supplies, 30 Wallace St., P.O. Box 322, Woodbridge, Ontario L4L IB2

Ferro Industrial Products Ltd., 354 Davis Rd., Oakville, Ontario, L6J 2X1

The Pottery Supply House, 2070 Speers Rd., Oakville, Ontario, L6J 5A2

UNITED KINGDOM

British Ceramic Service Co., Ltd., Bricesco House, Park Ave., Wolstanton, Newcastle, Staffordshire, ST5 8AT

R. M. Catterson-Smith, Ltd., Woodrolfe Rd., Tollesbury, Nr. Maldon, Essex CM9 8SJ

Cromartie Kilns Ltd., Park Hall Rd., Longton, Stoke-on-Trent, ST3 5AY

ECC International Ltd., John Keay House, St. Austell, Cornwall PL25 4DJ

The Fulham Pottery, Burlington House, 184 New King's Rd., London SW6 4PB

Kilns and Furnaces Ltd., Keele St., Tunstall, Stoke-on-Trent ST6 5AS

Podmore and Sons Ltd., Shelton, Stoke-on-Trent ST1 4PO

Podmore Ceramics Ltd., 105 Minet Rd., London SW9 7UH

Potclays Ltd., Brickkiln Lane, Etruria, Stoke-on-Trent ST4 7BP

Price and Kensington Potteries Ltd., Trubshaw Cross, Longport, Stoke-on-Trent ST6 4LR

Alec Tiranti Ltd., 70 High St., Theale, Berkshire (mail order works) 21 Goodge P1 W1, London (shop)

CONVERSION CHARTS

Metric Conversion Information

When You Know	Multiply by	To Find
inches	25.4	millimeters
inches	2.54	centimeters
feet	0.3048	meters
ounces	28.349	grams
pounds	0.453	kilograms
Fahrenheit (temperature)	0.5556 after subtracting 32	Celsius
fluid ounce	29.57	milliliters
quart	.9472	liters

Basic Metric Conversions

$\frac{1}{16}''$ = 1.6 mm

$\frac{1}{8}''$ = 3.2 mm

$\frac{1}{4}''$ = 6.4 mm

$\frac{1}{3}''$ = 8.5 mm

$\frac{1}{2}''$ = 12.7 mm

$\frac{3}{4}''$ = 19.1 mm

1″ = 2.5 cm

2″ = 5.1 cm

3″ = 7.6 cm

4″ = 10.2 cm

5″ = 12.7 cm

6″ = 15.2 cm

7″ = 17.8 cm

8″ = 20.3 cm

9″ = 22.9 cm

10″ = 25.4 cm

11″ = 27.9 cm

1 ft. = 30.5 cm or .3 m

200°F = 93°C

INDEX

Edited by Judith E. Royer
Graphic production by Hector Campbell
Text set in 12-point Century Expanded